KERRY

THE BEAUTIFUL KINGDOM

First published 2017 by The O'Brien Press Ltd

12 Terenure Road East, Rathgar,

Dublin 6, D06 HD27, Ireland

Tel: +353 1 4923333; Fax: +353 1 4922777

Email: books@obrien.ie

Website: www.obrien.ie

The O'Brien Press is a member of Publishing Ireland.

ISBN: 978-1-84717-930-2

Text and photography © John Wesson 2017

www.johnwesson.com

Copyright for typesetting, layout, editing, design

© The O'Brien Press Ltd

6 5 4 3 2 1

20 19 18 17

Printed and bound by Drukarnia Skleniarz, Poland

The paper in this book is produced using pulp from managed forests.

KERRY
THE BEAUTIFUL KINGDOM

JOHN WESSON

THE O'BRIEN PRESS
DUBLIN

Photographer John Wesson has been visiting and photographing Kerry for thirty years. Based in Derbyshire and Valentia, Co. Kerry, he is married with two grown-up daughters and can often be seen out and about with his dog, Bella. His work can be found online at www.johnwesson.com and in various galleries and outlets throughout Co. Kerry. This is his first book.

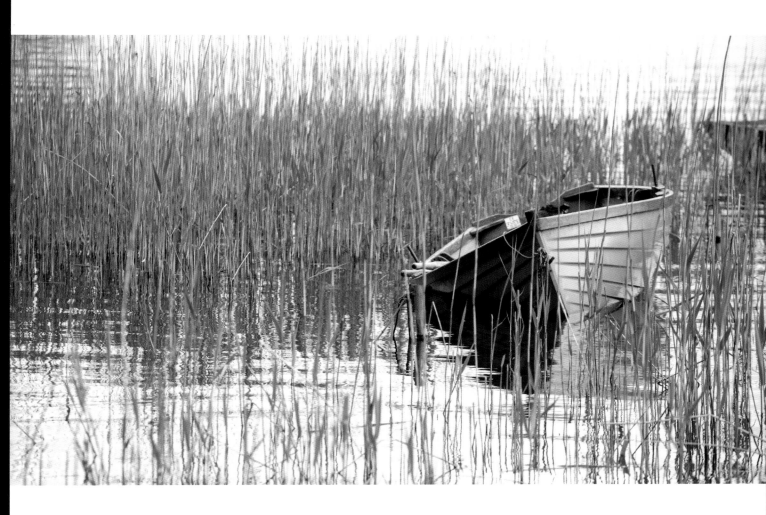

FOR DAVE

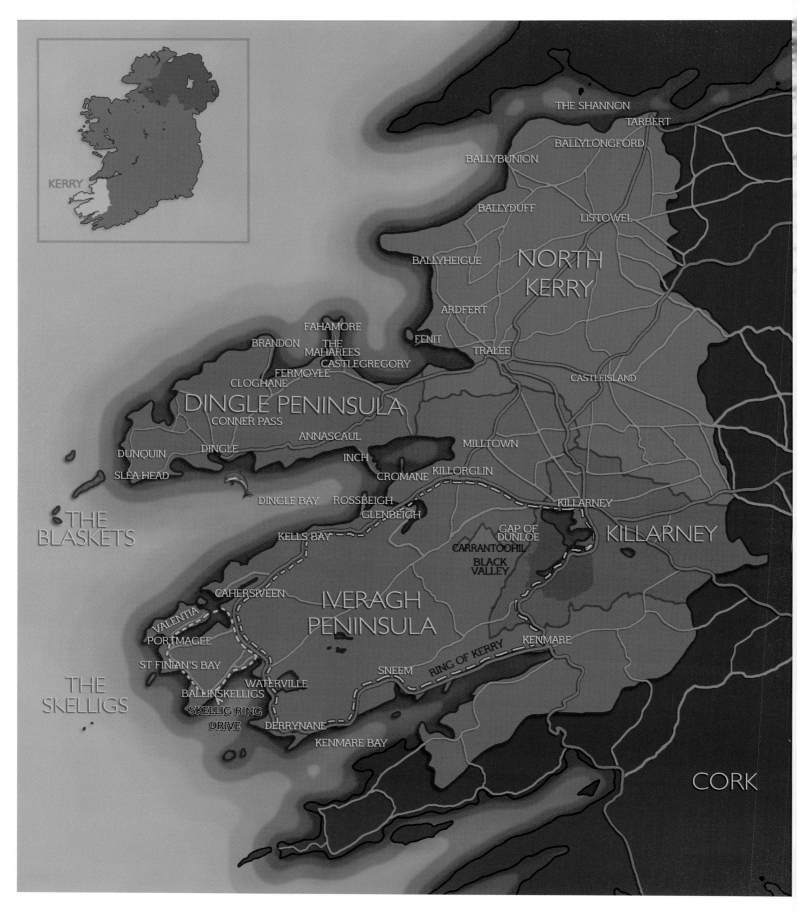

CONTENTS

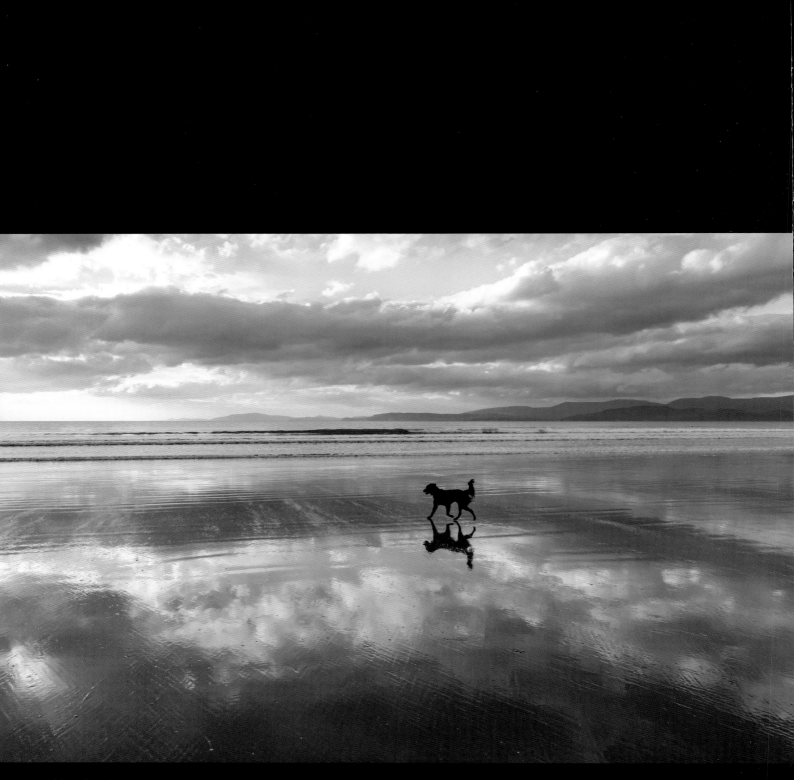

Here there is room to be alone . . . but never lonely. Why not bring the dog along too?

INTRODUCTION

I AM LUCKY ENOUGH TO HAVE HAD A LONG ASSOCIATION WITH KERRY, having returned on a regular basis for nearly thirty years. Each year I spend more and more time in 'The Kingdom'. In most of Kerry, and certainly in the south and west, you are never very far from the sea or from a mountain. The county rises rugged and mountainous out of the Atlantic Ocean. Cliffs and steep slopes abound, and safe, sheltered access is limited. In the north, the land is sweeter, less acidic and perfect for dairy farming.

The green fields of Ireland are green for a good reason: rain. It pours for days on end, sometimes for weeks. With the temperate oceanic climate, grass grows all year round, and conditions are perfect for rearing cattle and for milk production. Kerry's main export, food, is only possible because of copious amounts of annual rainfall. Most visitors come to Kerry to experience its raw beauty; they do not come for the weather. But a period of high pressure can lead to days of settled weather, and there are those who are lucky to have their visit coincide with fine weather.

If you are interested in landscapes and seascapes, Kerry is the perfect county. It is a joy to experience the astonishing and continually changing Atlantic light at first hand. My favourite times of the year to capture it are spring and autumn. This is when Atlantic showers blow in, bringing dark clouds that contrast with low, clean sunlight, illuminating the landscape in a way that has to be seen to be believed. It is possible to see more rainbows in a single morning here than in a whole year elsewhere.

Wintertime brings low light all day, picking out the landscape in rich, fine detail. The usually quiet beaches are now completely empty. Huge Atlantic rollers come crashing in, and the cold weather puts white hats of snow on the mountaintops. These mountains really do look remarkable; the golden hues of the dead, dried grasses and heathers look wonderful against a cold, blue sky. It is often asked how many shades of green are there in Ireland? I would also like to know how many shades of gold there are on a Kerry mountainside in winter.

Due to Kerry's westerly position, you will notice that it gets dark later than you might suppose, allowing plenty of time for a 'sundowner' while you admire the receding light … and take another sunset picture. Does the world need any more sunset pictures? I hope so.

There is a lot more to Kerry than just scenery. Its people are fierce and proud of all things 'Kerry', be it sport, culture or produce. The locals are friendly, enquiring, helpful people who will direct you, quiz you and learn all there is to know about you — all in no more time than it takes to order a Guinness or fold away a map. They are delighted to have so many people visiting from around the world, are interested in where they live and are always curious, given the chance, to find out where visitors come from and what they do for a living. A ten-minute chat with a local will most likely have you both informed and laughing in a way that simply does not happen elsewhere.

I have had a lifelong interest in photography, first picking up my dad's camera as a schoolboy and taking it on fishing trips to record the catch. I still have some black-and-white prints of those unfortunate fish. Cycling the lanes of Derbyshire looking for new places to fish or explore, my friends and I acquired an interest in the countryside in all its glory, flora and fauna — a passion that I still have today. Later, as an engineering apprentice, I bought my first SLR camera, a 35mm Canon FTb, along with a 50mm lens. It cost me a month's wages! It was a great camera that I used for years, and still own. I travelled the length and breadth of the British Isles with it, on various motorcycles. These days, I am still using Canon cameras, both full-frame and APS-C, and my subject matter is much varied. My favourite subjects are Irish seascapes and landscapes; however, I am interested in everything from weeds to weddings.

I hope that my enthusiasm for the Kerry landscape, people and wildlife is portrayed through this book and helps you, the reader, to a greater appreciation of 'The Kingdom'. There is an 'edge' here, an anticipation. Who knows what you might find around the next bend, or over the next hill? My desire for the perfect image has never diminished, and the quality of the constantly changing light suggests that the search will continue for many years to come. Here is Kerry: with its big skies, huge vistas and big-hearted people.

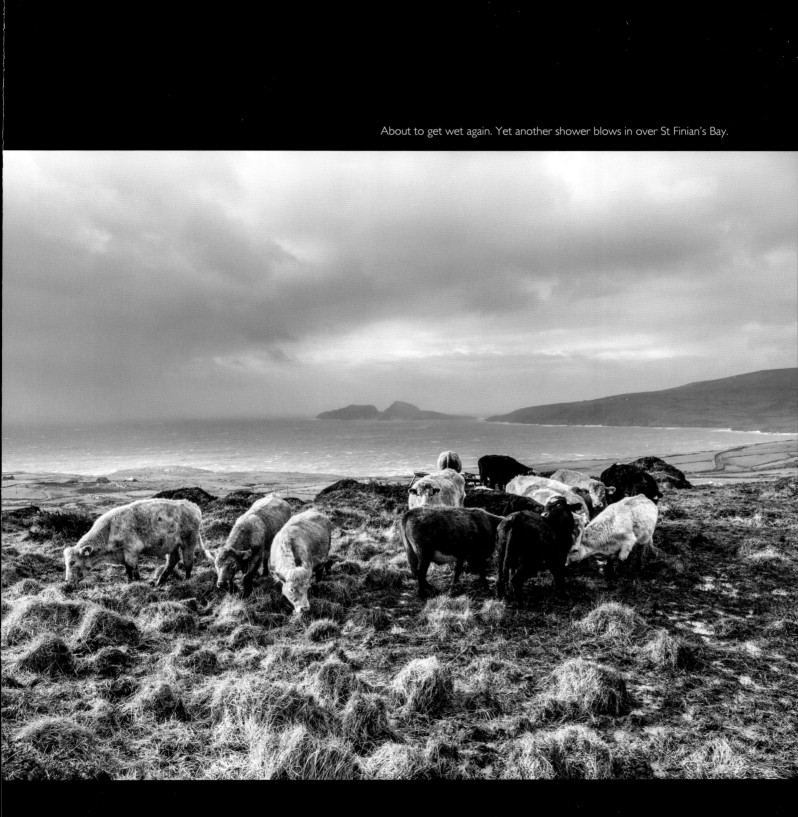

About to get wet again. Yet another shower blows in over St Finian's Bay.

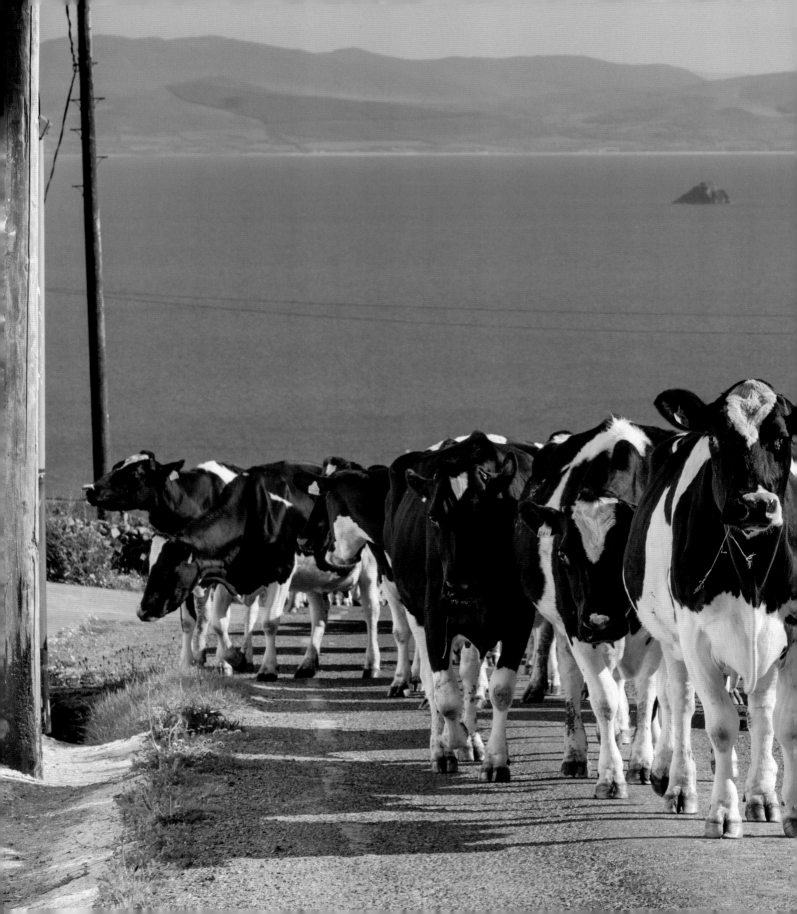

NORTH KERRY

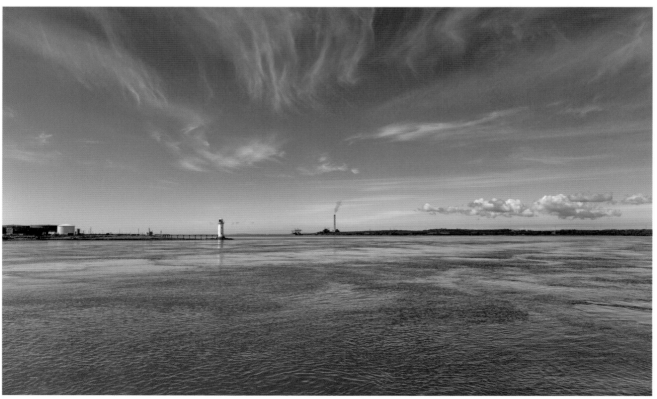

LESS MOUNTAINOUS THAN THE REST OF THE COUNTY, from the Shannon to Tralee is lush, rolling, verdant green countryside. History, heritage, culture and scenery are all around you, with many Blue Flag beaches for bathing, surfing and angling. Kerry's 'gold' is found here — be it the 'written word' or the finest dairy produce in the world.

TARBERT

Opposite top: What better way to enter the Kingdom than by crossing the vast Shannon, Ireland's mightiest river? You can sail from Killimer in Co. Clare to Tarbert, Kerry's northernmost point.

Opposite bottom: Shannon Estuary.

Below: Tarbert Bridewell, now a visitor centre and café.

Previous page: Friesian cattle heading back to their fields after milking.

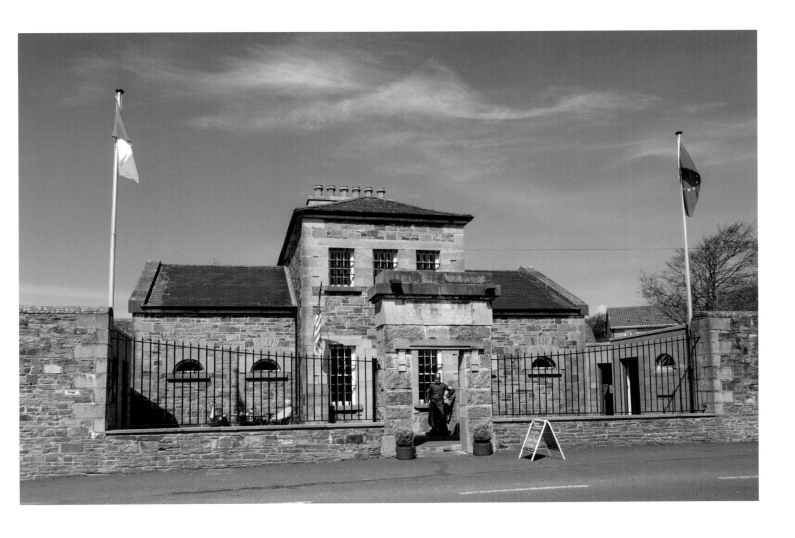

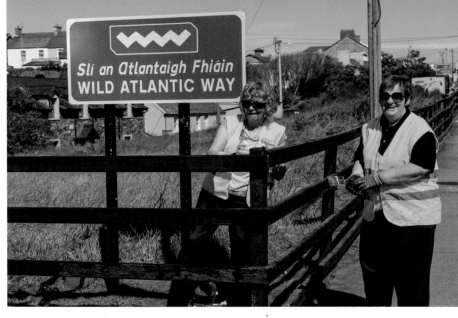

BALLYLONGFORD

Above left: River cottage, Ballylongford.
Right: Tidying the Wild Atlantic Way.

BALLYBUNION

Below: Ballybunion beach and castle. Built in the sixteenth century,
the castle was severely damaged by a lightning strike in 1999.

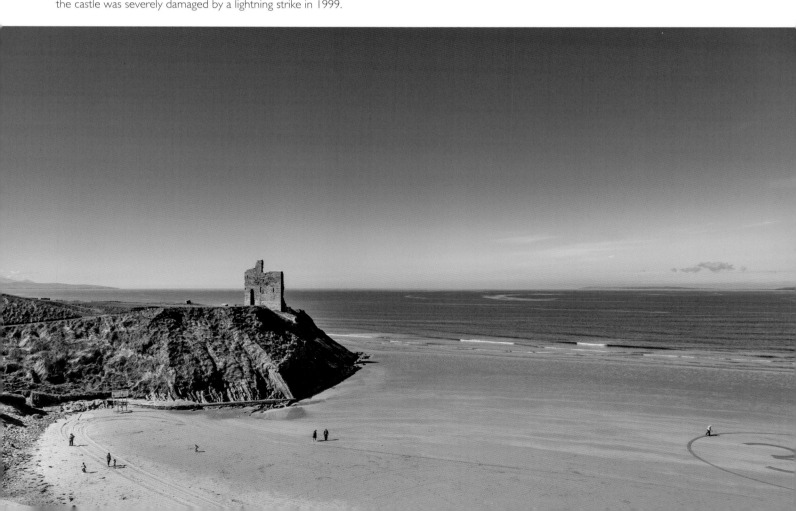

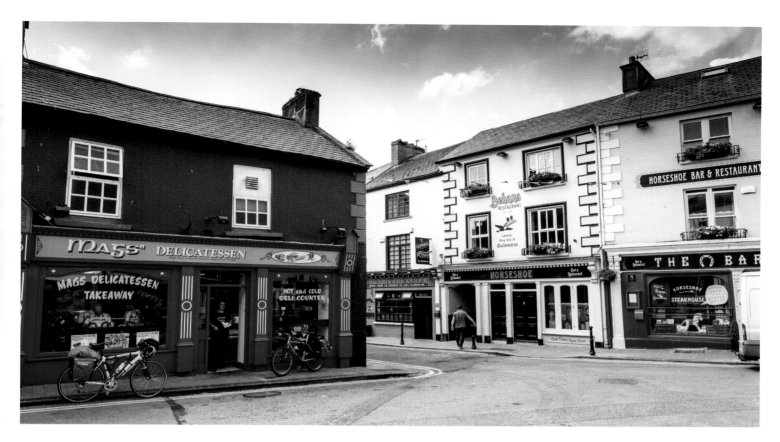

LISTOWEL

Above: Listowel is often described as the literary capital of Ireland. The birthplace of writers John B. Keane (1928–2002) and Bryan MacMahon (1909–98), it has become a hive of creative expression – a location where, in the words of Keane, 'it is easier to write than not to write.' The town hosts Ireland's leading literary festival, Listowel Writers' Week, every year. Founded in 1970, the festival has hosted many revered writers, including poet and Nobel Laureate Seamus Heaney, Poets Laureate Ted Hughes, Andrew Motion and Carol Ann Duffy, as well as writers, poets and playwrights such as Edna O'Brien, Roger McGough, Tom Murphy, Brian Friel, Roddy Doyle, Frank McGuinness, Irvine Welsh and Hugh Leonard. There are lectures, seminars, book launches and workshops, as well as plays, literary and historical tours and exhibitions of art, music and dance. Listowel Writers' Week attracts a large crowd every year due to its diverse and wide-ranging programme, combined with the very friendly atmosphere.

Right: Listowel Castle.

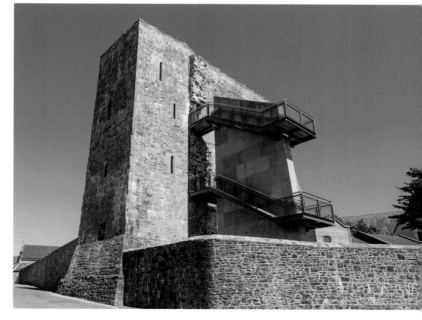

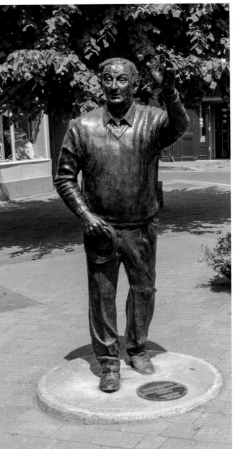

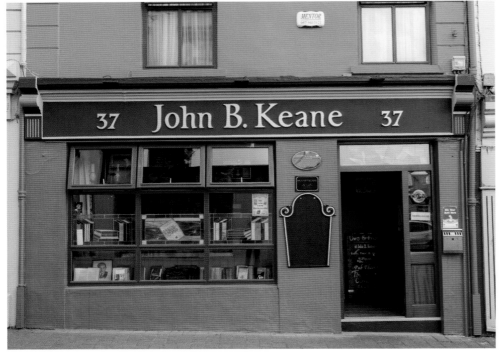

Top: The Listowel Arms Hotel.

Above: John B. Keane's pub.

Top right: Statue of playwright John B. Keane.

Right: Lunch-break ladies.

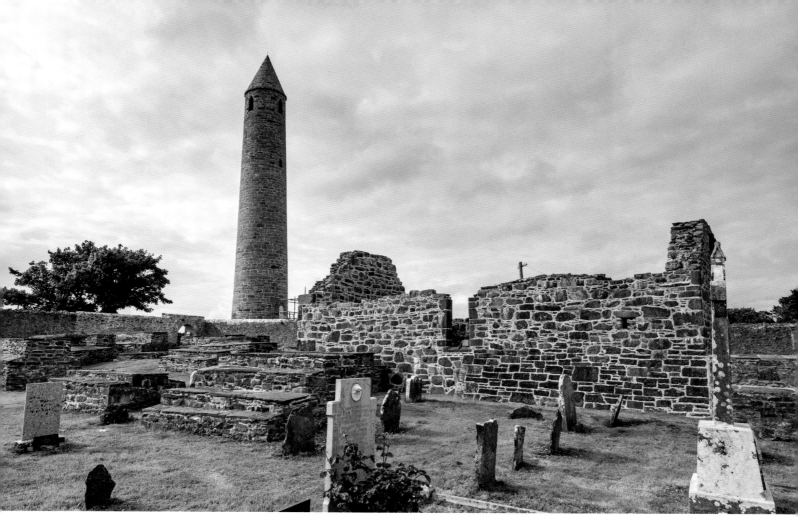

BALLYDUFF

Above: Standing 28 metres tall, and nearly 1,000 years old, the Rattoo Round Tower, near Ballyduff, is built on the site of an early monastery. The nearby church ruins are fifteenth-century.

Right: The oxeye daisy, a pretty but rather invasive plant.

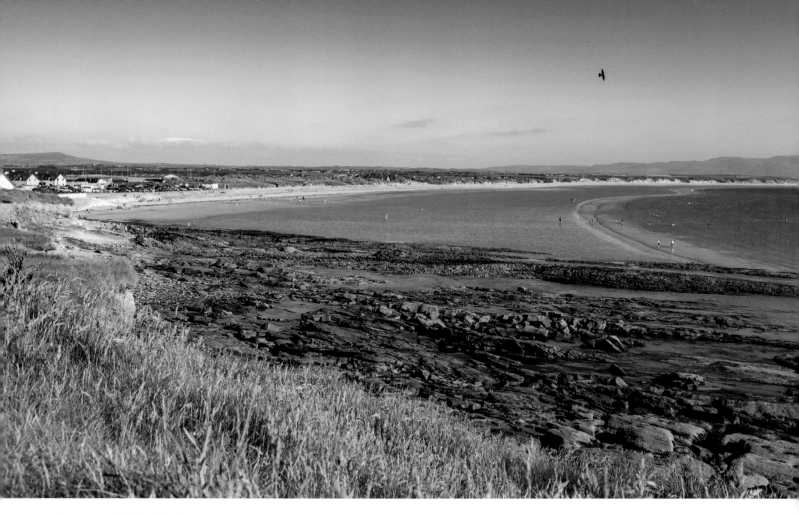

BALLYHEIGUE

Above: Ballyheigue is very much a 'resort' village with its castle and surrounding golf course overlooking it and its Blue Flag beach, considered to be one of the safest in Kerry. The beach stretches past the sand dunes to Banna Strand in the south and almost as far as Kerry Head in the north.

Opposite top: It is believed that donkeys first arrived in Ireland from Britain, having been brought by the Romans from the Middle East and the Mediterranean. They soon became loyal, hardy and sturdy working farm animals: hauling seaweed for fertiliser, turf from the bog for fuel and anything else that needed to be moved to village or farm. They can get by on poor grazing, which is just as well, as they often have to.

Opposite bottom: These pretty cottages are well placed, looking directly over the beach.

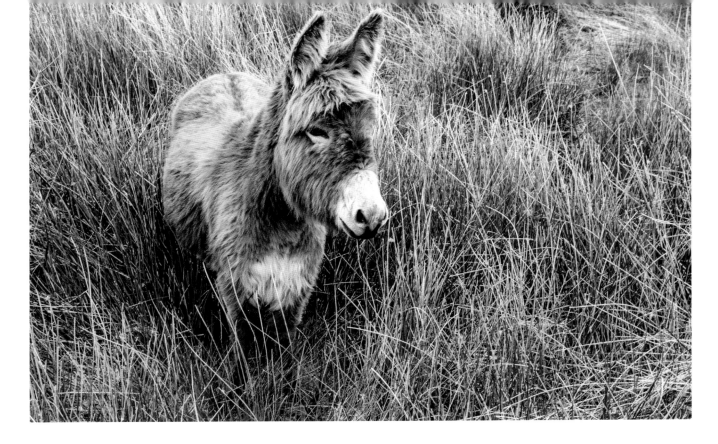

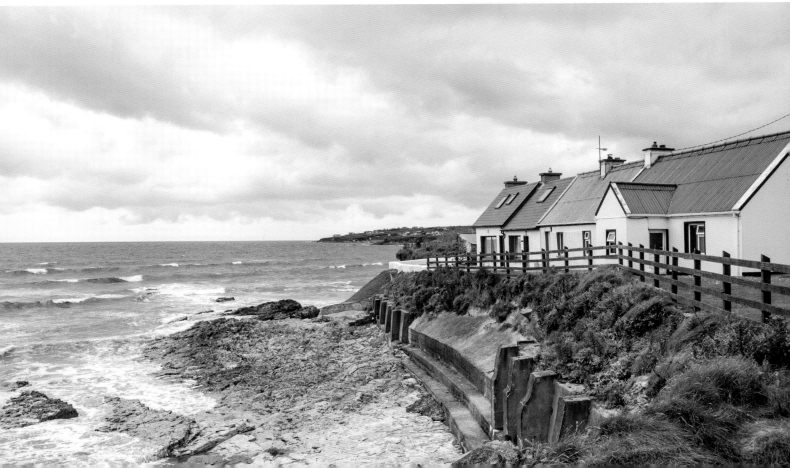

ARDFERT

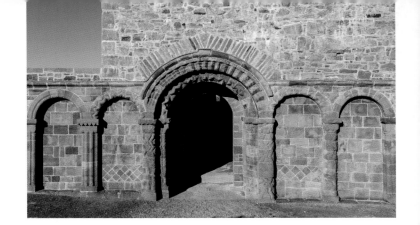

Top right: St Brendan founded a monastery at Ardfert in the sixth century AD. What we see standing today dates largely from the eleventh, twelfth and thirteenth centuries as it has been constantly modified and added to over the years.

Right: The Glandore Gate once stood as one of the entrances to the Crosbie family mansion. The Crosbies, who were governors, councillors and landlords, were in Ardfert for nearly 300 years. This splendid building was relocated to its central village location in the 1880s and is now a private house. Like the cathedral, the first Crosbie mansion was destroyed by fire in the 1641 Irish Rebellion. In 1922, the IRA destroyed the replacement mansion.

Below: Ardfert Cathedral. Constructed from limestone and sandstone, the battlements were built in the fifteenth century. The windows and fine carvings declare the building's status – Ardfert was the medieval capital of Kerry. During the Irish Rebellion of 1641 the cathedral was destroyed by fire and abandoned.

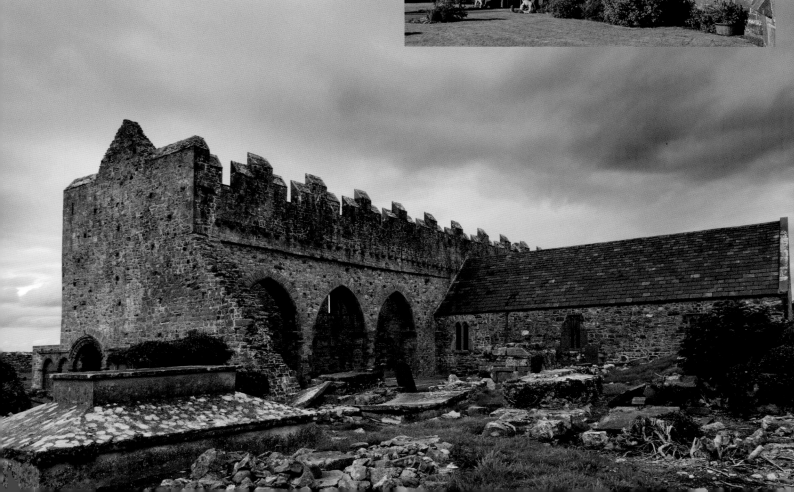

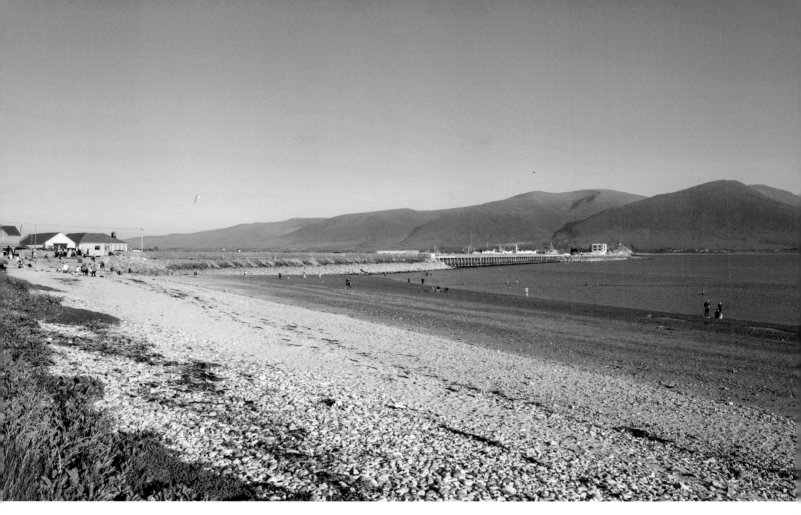

FENIT

Above: Fenit, the most westerly commercial port in Europe, was at one time a major port for the Irish fishing industry. This is no longer the case due to changes in EU quotas. Irish patriot and hero Sir Roger Casement unsuccessfully attempted to land arms near here for the 1916 Easter Rising, arriving himself by German submarine. Today, Fenit is home to a modern marina that caters for leisure craft.

Right: Saint Brendan 'The Navigator' points west into the setting sun. A local lad and accomplished sailor, like St Patrick before him, Brendan spread the word of Christianity to Wales, Scotland and France. Legend has it that in the sixth century he set sail from near here (Brandon Harbour) along with a crew of followers in a boat made from wood and leather, discovering Greenland and America nearly 500 years before the Vikings and 1,000 years before Christopher Columbus. True or not, it is certainly a good story.

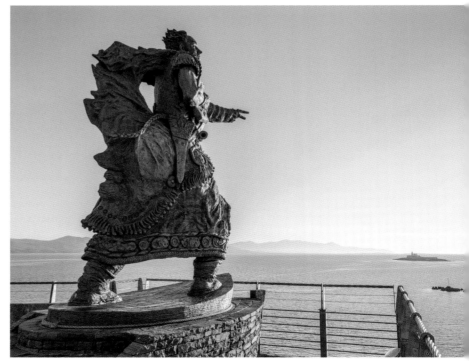

Little Samphire Island Lighthouse is now open to the public – a twenty-minute boat ride.

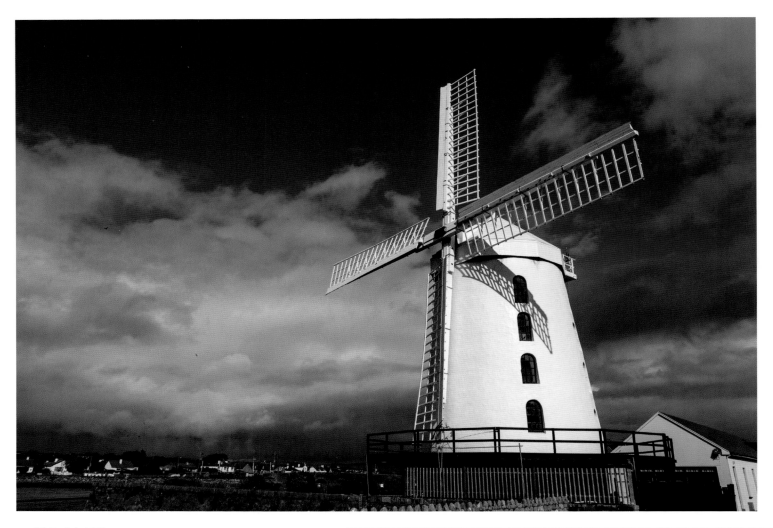

TRALEE

Tralee is the administrative capital of the county, with the main institutions all being located here. It is most famous for the Rose of Tralee Festival each August which draws contestants and friends from across the globe and has now established a worldwide franchise.

Above: Blennerville Windmill, dominating the local skyline. Built in 1800, this commanding structure stands guard at the start of the Dingle Peninsula, where Tralee meets the sea. After many years in ruin it was restored in the late 1980s and reopened in 1990. There is now a visitor centre, and the milling process can be observed from start to finish. As the only commercially operating windmill in Ireland, the mill is also the tallest of its kind in Europe. Nearby is the Tralee Bay Wetlands nature reserve.

Right: Kirby's Brogue Inn.

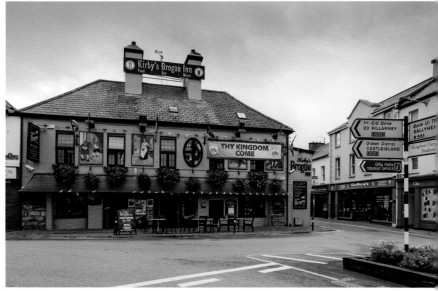

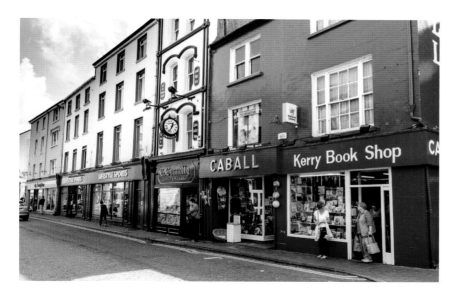

Above: Bridge Street.

Right and above right: Shop windows, Tralee. Gaelic football is a passion shared by all in Kerry, and the county team is the most successful of all time. If they are heading for the All-Ireland Final (for yet another year), you will know about it. Shop windows, cars and houses are painted green and gold and hung with bunting and flags in support.

Bottom right: St John's.

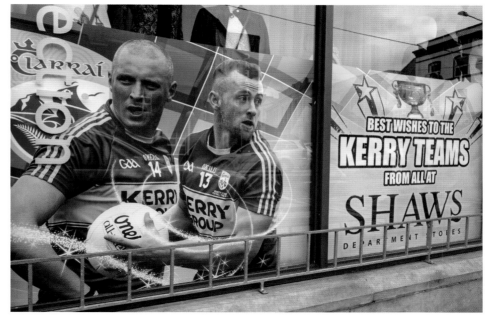

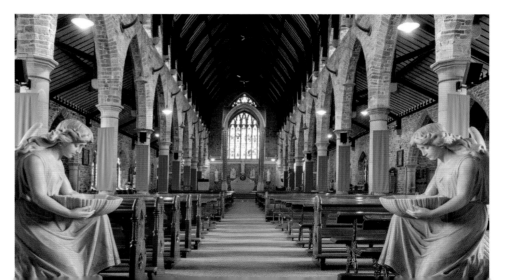

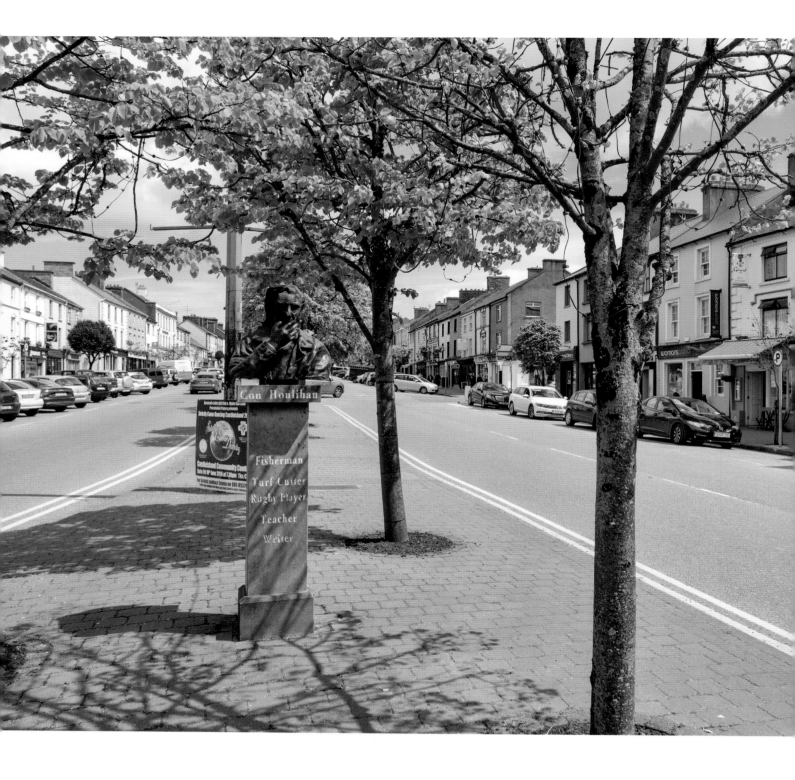

CASTLEISLAND

Left: Journalist, commentator and sports writer Con Houlihan (1925–2012) was never less than exceptionally entertaining. His bust is situated on 'the street between two fields' – his own less than flattering description of his home town of Castleisland. The plaque reads, 'Fisherman, Turf Cutter, Rugby Player, Teacher, Writer'.
Below: The Curiosity Shop, Castleisland.

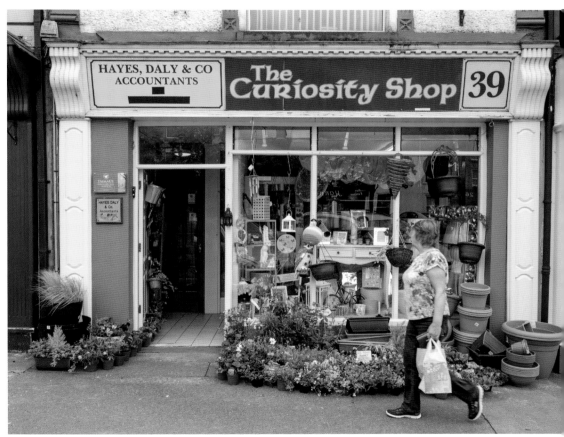

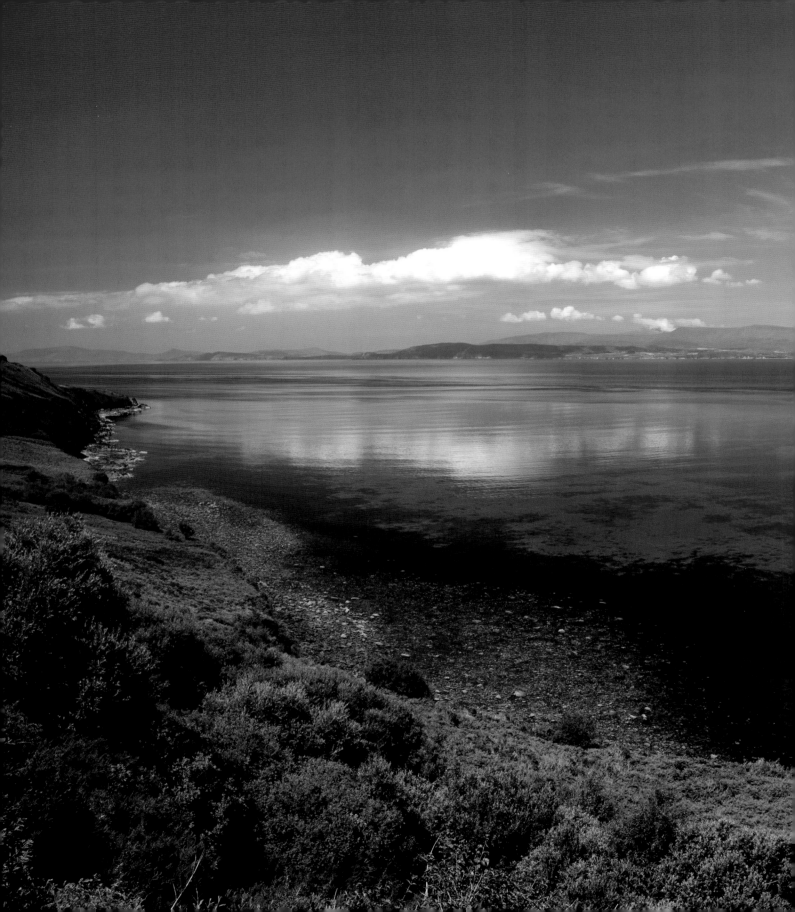

THE DINGLE PENINSULA

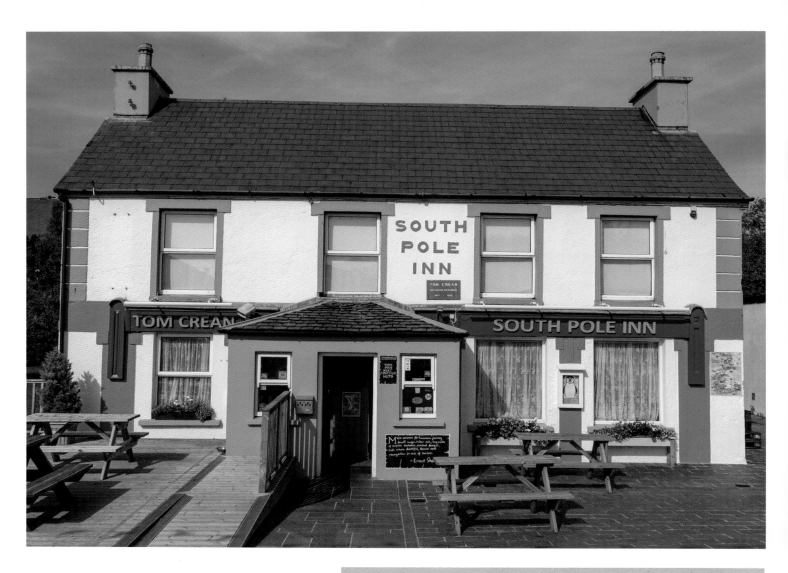

MEN WANTED for hazardous journey small wages, bitter cold, long months of complete darkness, constant danger, safe return doubtful, honour and recognition in case of success.

— Ernest Shackleton

THE DINGLE PENINSULA IS THE WESTERNMOST POINT OF EUROPE and a must-see for all visitors to Ireland, and certainly to Kerry. It is a little over 50 kilometres, as the crow flies, from Castlemaine to the very picturesque Dunmore Head, with the Blasket Islands just beyond. The mountains are its backbone, Mount Brandon being the highest and visible for many miles north and south. Along the way are Annascaul, Dingle, Ventry and numerous other small villages and pockets of interest, including Iron Age settlements, early Christian beehive huts, the Conner Pass, beaches and the award-winning Blasket Centre.

ANNASCAUL

Opposite top: The county is rightfully proud of polar explorer Tom Crean, who accompanied Ernest Shackleton on his Imperial Trans-Antarctic Expedition, also known as the Endurance Expedition, to the South Pole in 1914–17, an expedition dogged by bad luck and adversity. The explorers failed to reach the South Pole and yet in spite of losing their ship, *Endurance*, and virtually all of their possessions, they survived and made it back home without a single loss of life.

Opposite bottom: Ernest Shackleton's job advertisement – most likely apocryphal.

Bottom: Dan Foley's pub, now abandoned.

Previous page: Dingle Bay from Mountain Stage on the Ring of Kerry.

INCH

Below: Inch Beach is another 'must see', and there is no reason not to, as the road from Castlemaine to Dingle runs right past it. It is five kilometres of spectacular, bleached and unspoilt shoreline, immortalised in the epic film *Ryan's Daughter*.

Right: Sammy's Bar, Restaurant, and Café, Inch Beach.

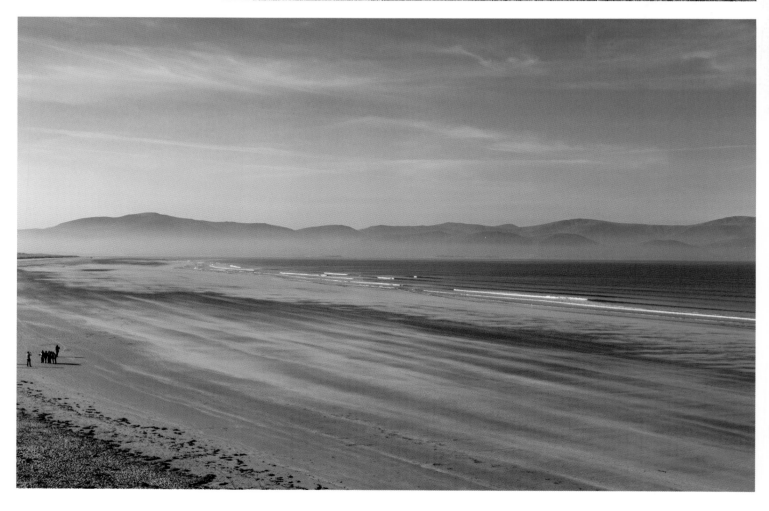

DINGLE BAY

Above: Dingle Bay is the most famous stretch of water on the west coast of Ireland. Visitors from near and far are compelled to stop, look and marvel at this huge vista with its ever-changing light. In fact, if you are in no hurry (and nothing should be hurried in Kerry), this is a very good place to take a break, sit back, watch and wait – especially in 'mixed' and unsettled weather. Watch the transformation before you, minute by minute, with showers and clouds rolling in, great shafts of sunlight and huge, often double, rainbows. Here, there will often be a downpour blackout followed rapidly by bright sunshine.

Right: Dingle dawn.

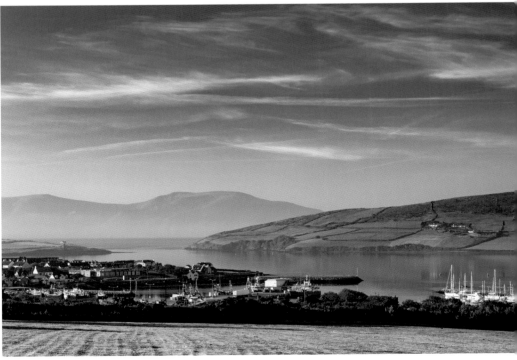

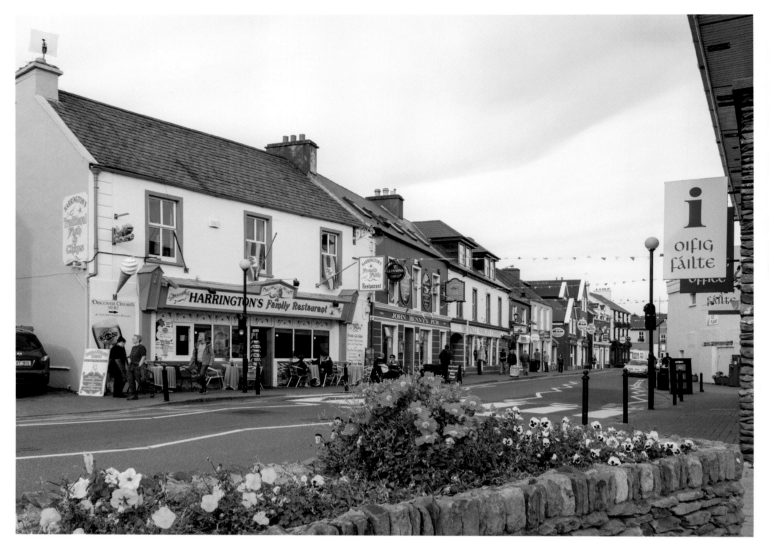

DINGLE

Above: Dingle is a truly charming town, with independent outlets selling local produce and probably more pubs per head of population than anywhere else in Ireland. It is certainly the place to be for a good night out.

Right: Hedi, Dingle Pottery, Green Lane.

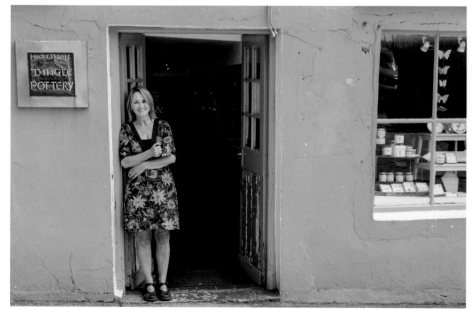

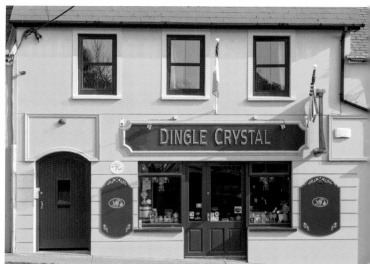

Above left: Not for everyone, cycling is a very enjoyable way to relax and explore the county.

Above right: Dingle Crystal.

Below: John Benny's Pub, Strand Street. All visitors to Ireland, and to Kerry in particular, should visit the local pub. The pub is a huge part of Kerry culture and is not to be missed. The best advice I can give to first-timers is, 'Stay at the bar!' Don't go and sit in the corner or out of the way somewhere. The bar is much more than just a place to buy a pint of Guinness. You will soon be engaged in conversation. It will start off at first by polite enquiries about where you are from, where you are staying, the weather, etc. Next will come various suggestions, places for you to visit, eat, things to do, things not to miss – all in all, a lot that a guidebook could not hope to cover or even be aware of.

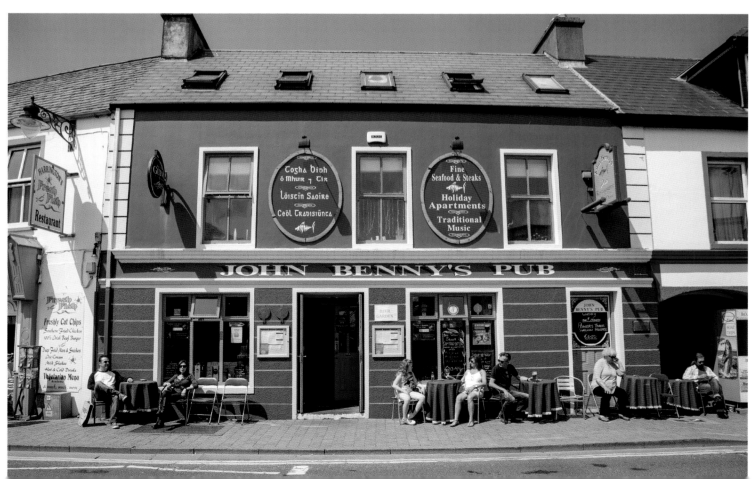

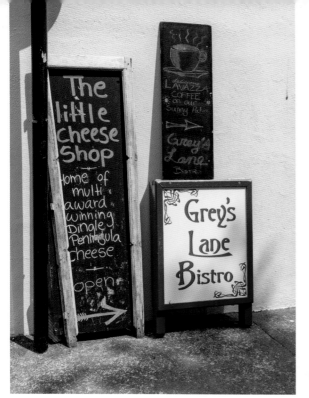
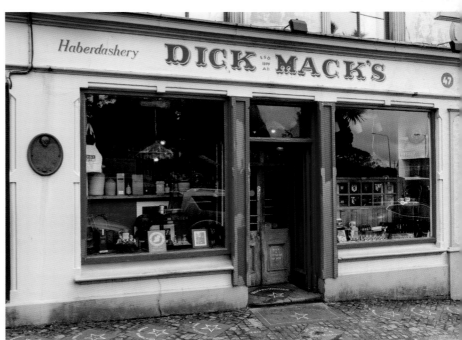
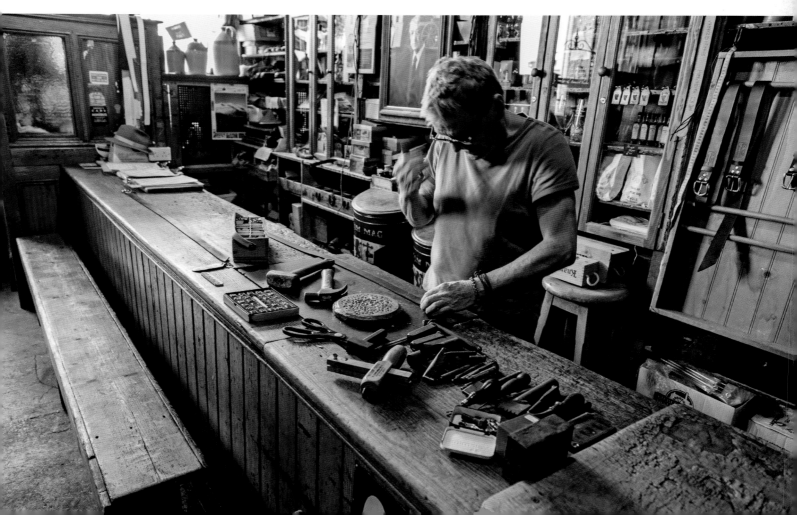

Opposite top left: Signs, Grey's Lane. Who can resist a little cheese?

Opposite top right: The legendary Dick Mack's on Green Lane. Opened in 1899 by Tom MacDonnell, the pub provided refreshments for passengers of the Dingle Light Railway and Tramway. The pub became a boot store when it was taken over by Tom's son, Richard, in 1938. His name went up above the door – edited somewhat for aesthetic purposes.

Opposite bottom: Today the pub is lined with shelves filled with an array of shoes, buckles, tools and nails. Guinness is in plentiful supply, as well as custom-made leather belts, should you require one.

Right: Oliver MacDonnell, Dick Mack's son and owner of the pub, well dressed as ever.

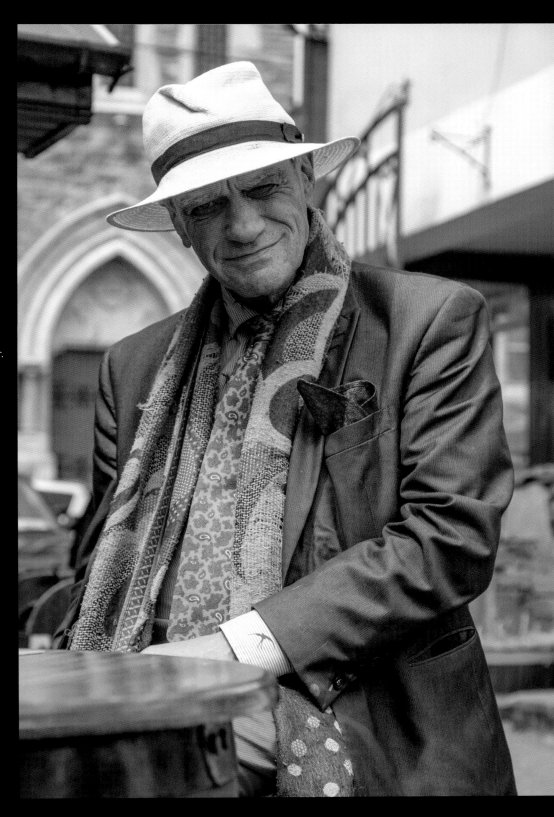

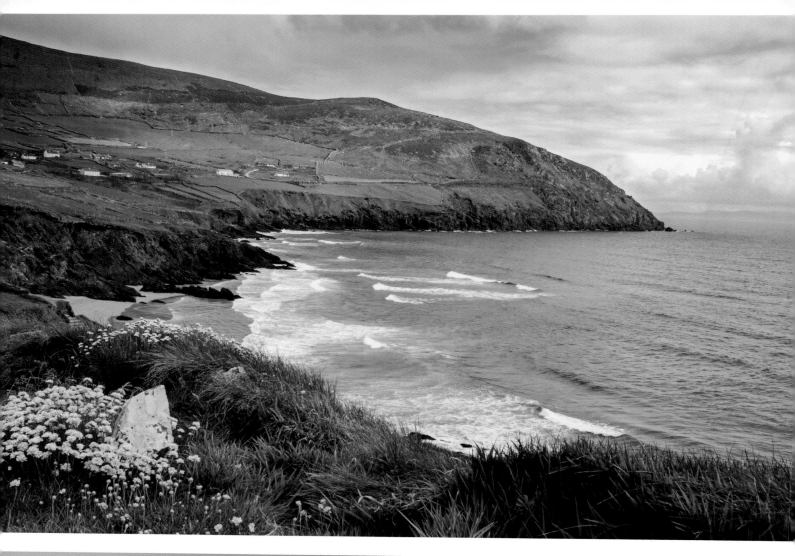

SLEA HEAD

Above: Slea Head, seen from Dunmore Head.

Left: Look out for the herring gull, sitting on the wall. He is a regular here and is waiting for a piece of your sandwich.

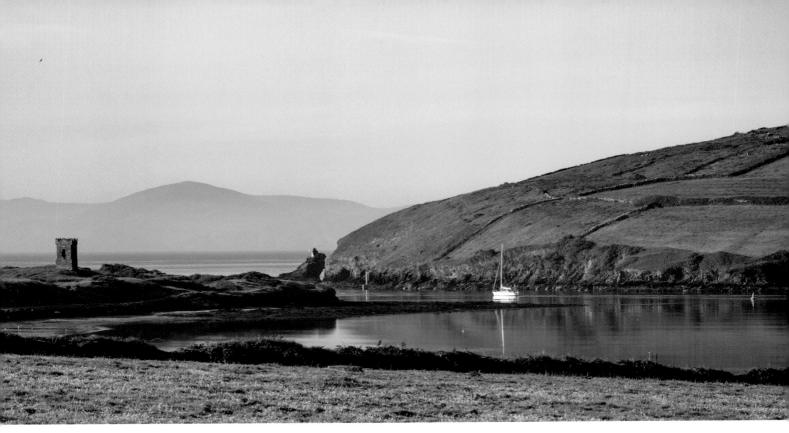

Above: Dingle Harbour.

Right: Fungie, the bottle-nosed dolphin, first appeared in Dingle Harbour in 1983. A free spirit, he has the entire ocean and yet he chooses to stay and live in the harbour, much to the delight of local boatmen who in the summer make a living from taking tourists out to meet him.

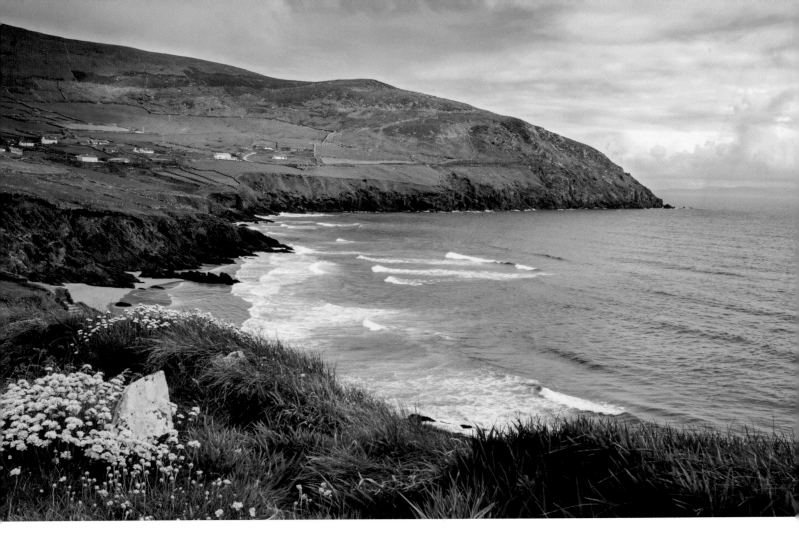

SLEA HEAD

Above: Slea Head, seen from Dunmore Head.

Left: Look out for the herring gull, sitting on the wall. He is a regular here and is waiting for a piece of your sandwich.

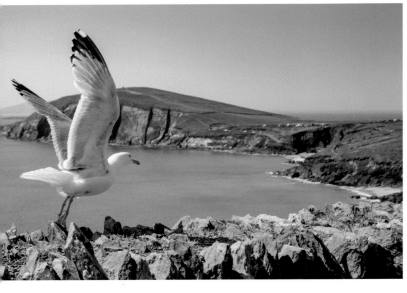

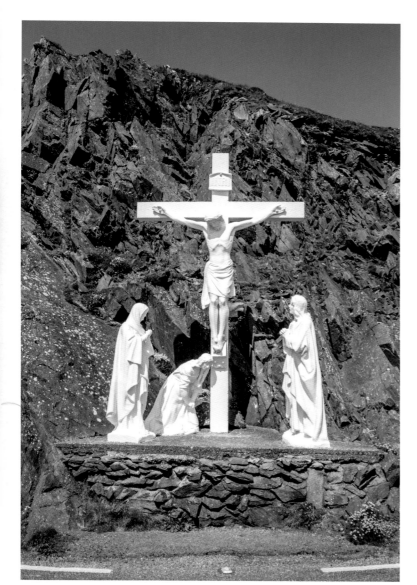

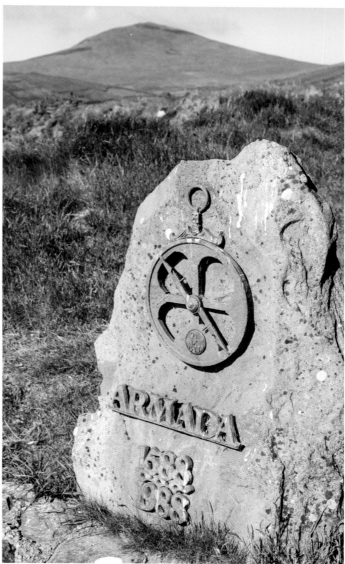

Above left: The life-size crucifixion at Slea Head is a memorial to fishermen who have lost their lives at sea.

Above right: Following its defeat at the battle of Gravelines in 1588, what was left of the 130 ships of the Spanish Armada sailed past the headlands here after circumnavigating the British Isles. Numerous ships sank, and thousands of crew perished. Those survivors who managed to escape the wild sea and make it to the shore were no luckier as they were then put to death.

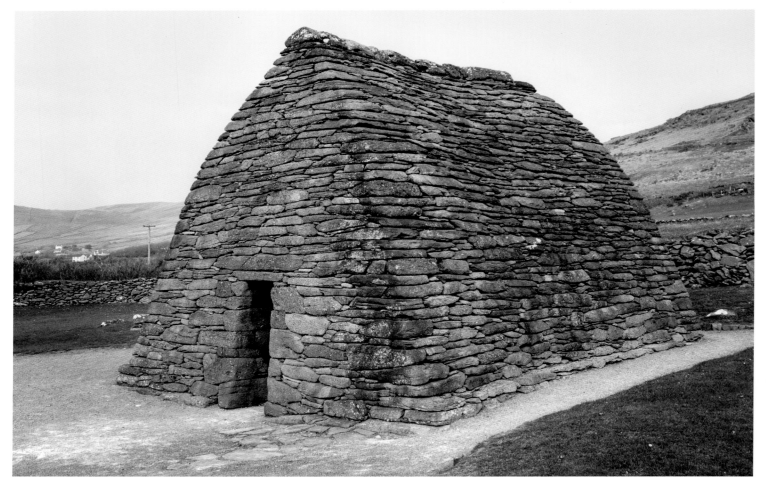

DUNQUIN

Above: Gallarus Oratory is one of the most famous landmarks on the Dingle Peninsula. Compared by some to an upturned boat, it was discovered in 1756 by Charles Smith. Some say that it was an early Christian church, although there is no identified reference to the oratory prior to its discovery by Smith. The corbelled, vaulted construction is similar to *clogháns* (beehive huts), although with a finer and more sophisticated finish. Access to the oratory is available all year round, and there is also a visitors' centre on site.

Left: Stone cross and shrine at Dunquin.

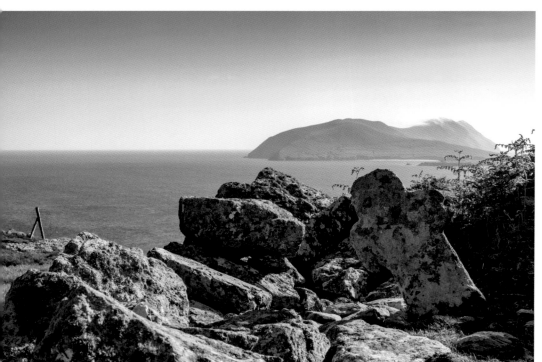

Right: A slightly dishevelled and overworked mother stonechat near Dunquin. She is doing her best to ward off an intruding photographer.

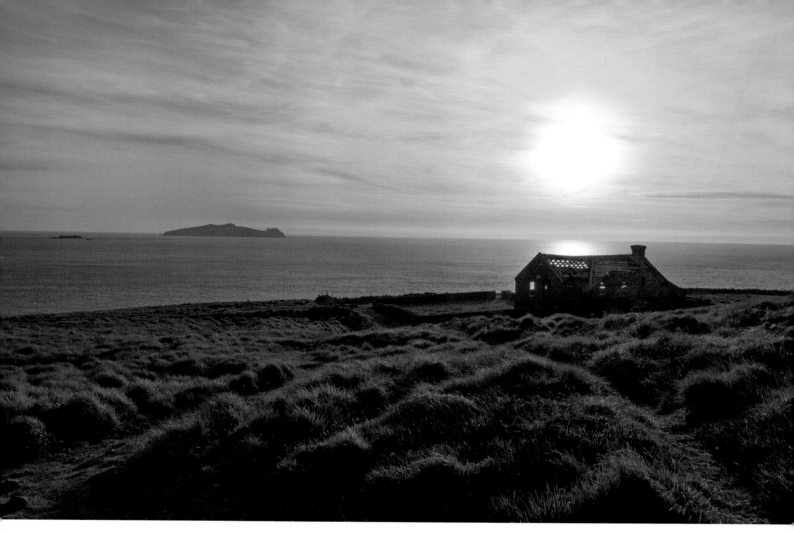

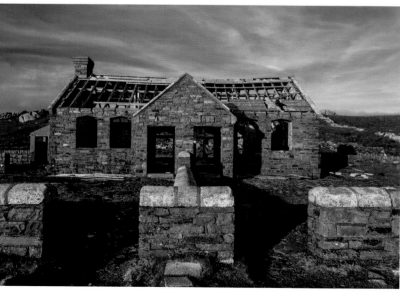

Above: David Lean's Oscar-winning film *Ryan's Daughter* (1970) was made in Dingle. His Super Panavision cameras captured Dingle's exquisite scenery with its 'big skies' magnificence in a way that has yet to be equalled, making the location the true star of the 1970 blockbuster, quite an achievement considering the 'A' list actors involved: Robert Mitchum, Trevor Howard and Sarah Miles. Many films have been shot on location here both before and since, including *The Playboy of the Western World* (1962) and *Far and Away* (1992). More recently, filming has taken place for the latest in the Star Wars trilogy by J. J. Abrams at Ballyferitter.

Left: This is the schoolhouse that was built for and used in the filming of *Ryan's Daughter*.

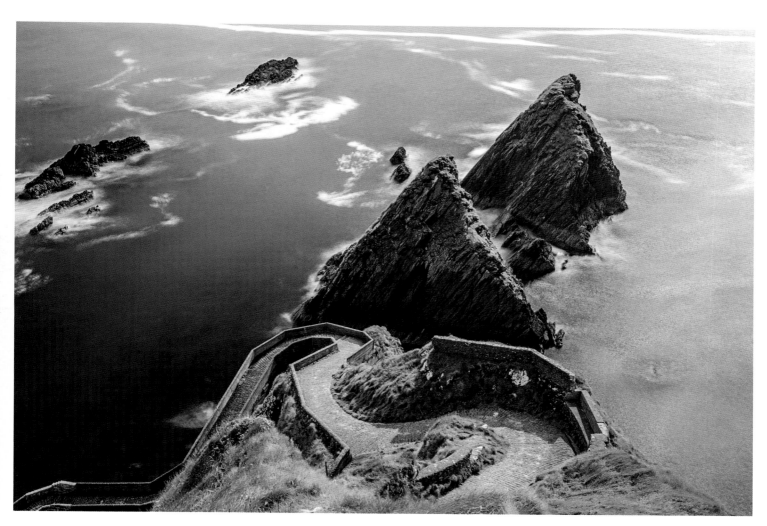

Above: Twists and turns down to Dunquin Pier.

Right: It is hard to imagine a more idyllic place of work than Sibéal's selling boat rides out to the Great Blasket, the only island open to visitors. Perched high on the cliff above Dunquin Pier, Sibéal's shed looks out over the Blasket Islands and the Atlantic Ocean.

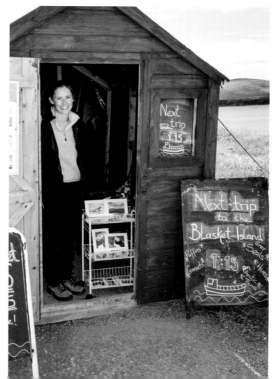

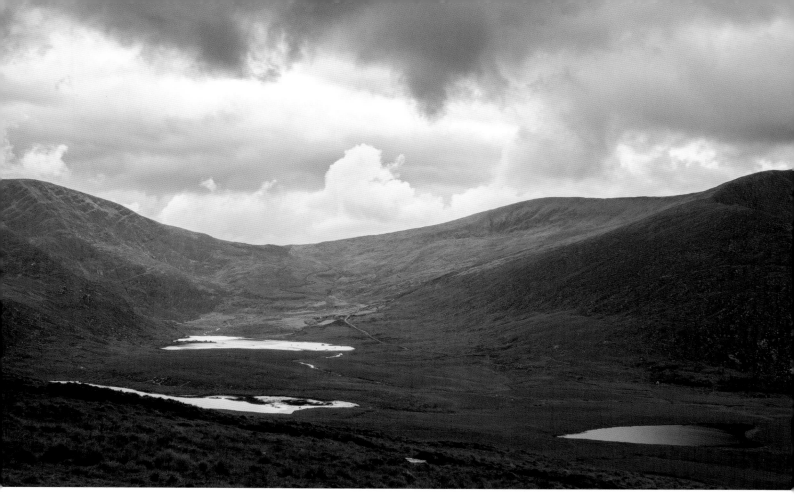

CONNER PASS

Above: Conner Pass lakes.

Left: Conner Pass is the highest mountain pass in Ireland and a very tight and twisty drive, which conveniently opens out to a small pull-in area that allows you to view the waterfall and the surrounding scenery.

Below: Waterfall and Conner Pass.

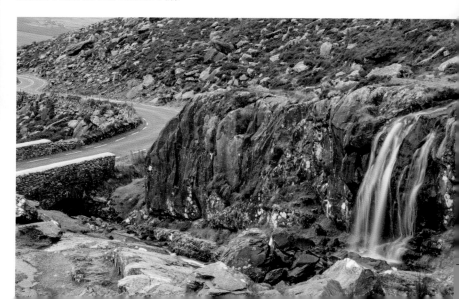

CLOGHANE

Top right: In 1940, during the Second World War, a German Focke-Wulf plane on reconnaissance suffered engine problems and managed a successful crash landing on the slopes of Mount Brandon. The crew survived, and some stayed in Ireland. The last of their number died in 2010.

BRANDON

Right: First introduced into Ireland in the mid-1800s, the black-faced mountain sheep is the most common breed in Kerry. Its long, coarse fleece enables it to survive the harshest weather in the toughest mountain conditions. Living a life in the wild, the ewes make very good mothers and are unafraid to defend their young if they feel threatened. Looking like so many 'woolly boulders' when scattered across a mountainside, seen up close they often have bright high-vis colour patches, denoting the individual owners. Most are exported to Europe for meat, with France and the UK taking the majority.

Below left: Brandon Harbour.

Below right: Shearing keeps the sheep cool in the summer. Although the wool is sold on, the price paid to the farmers is poor.

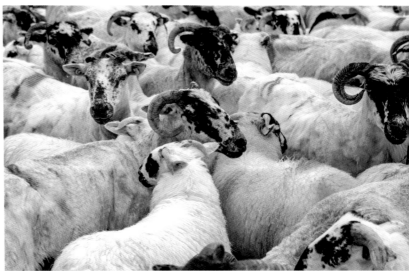

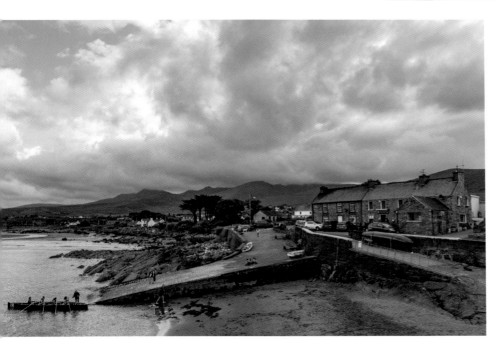

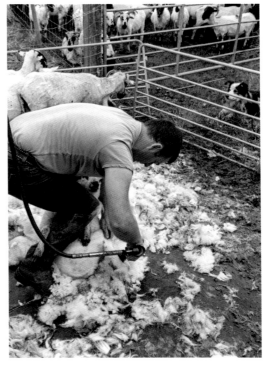

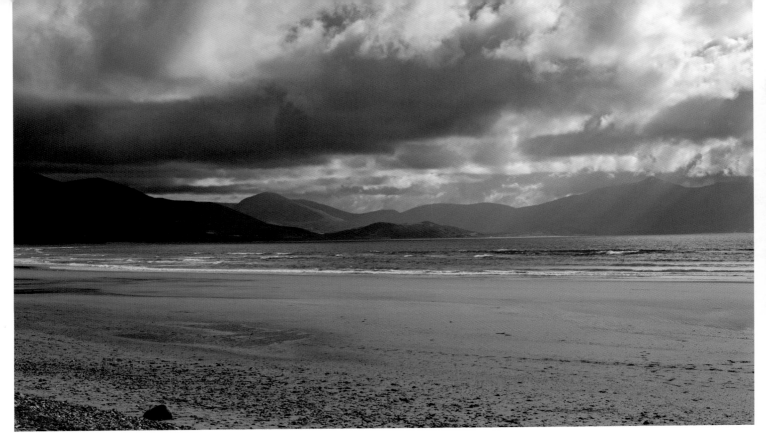

FERMOYLE

Above: Fermoyle Strand is a 22-kilometre stretch of beach from Fermoyle, past Caslegregory and down to the Maharees Peninsula. It is the longest beach in all of Ireland.

CASTLEGREGORY

Right: Roadside grotto near Castlegregory. Castlegregory is located at the base of the Maharees sandy peninsula, with Brandon Bay to the west and Tralee Bay to the east.

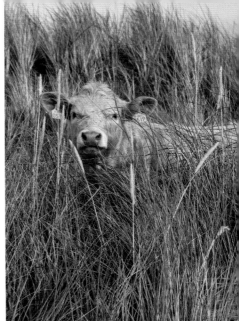

THE MAHAREES

Above left: With its rich, sandy soil, the Maharees are the best area for growing root vegetables in the county. Roadside stall-holders selling early vegetables will have likely sourced their produce here.

Above right: Maharees calf – two ear tags in case one should fall out!

FAHAMORE

Below: Sunrise over Dingle Peninsula, viewed from the Great Blasket.

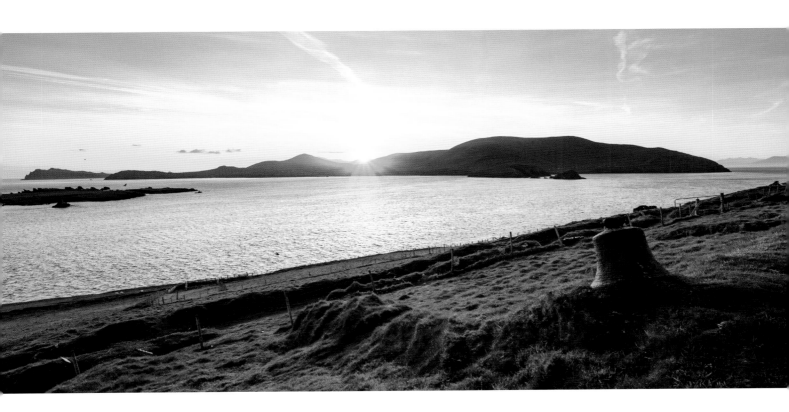

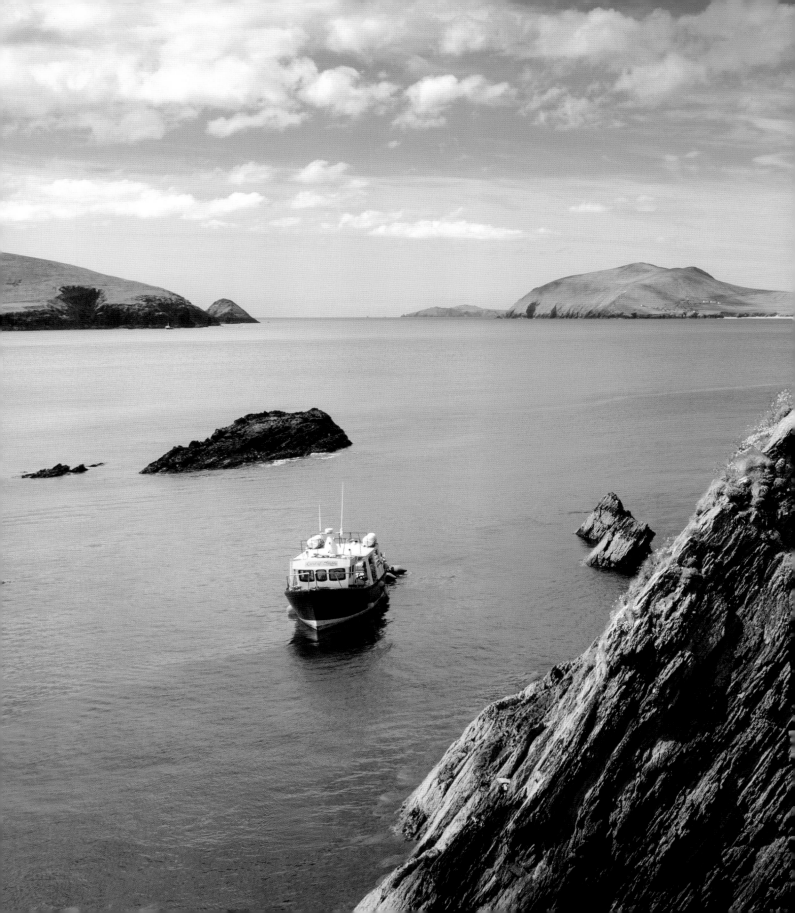

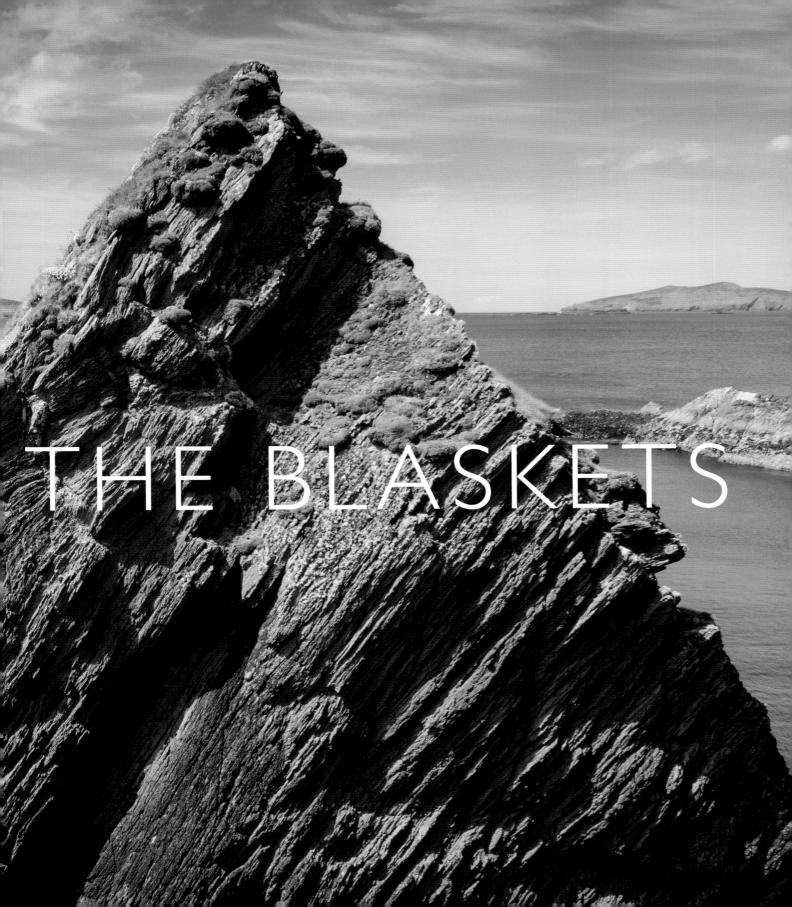

THE BLASKETS

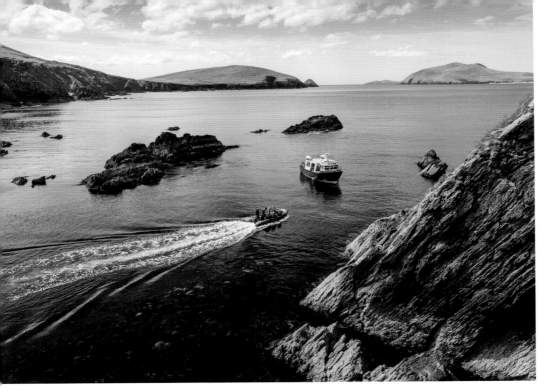

THE BLASKETS

Left: Passengers being transferred to the Blasket ferry. The Blasket Islands consist of six islands: the Great Blasket, Beginish, Inishvickillane, Inishtooskert, Inishnabro and Tearaght Island. The largest of the islands, the Great Blasket, can be visited during the summer months. Boat trips can be taken from Dunquin, Ventry and Dingle, Dunquin being the nearest point with a crossing taking about twenty minutes.

Below: Ruins of a village. Due to the harsh conditions and lack of electricity and other basic amenities, the islanders gradually departed, many for England or America. The islands were finally completely abandoned in 1953.

Previous page: The Blasket ferry.

Opposite: Living on the edge.

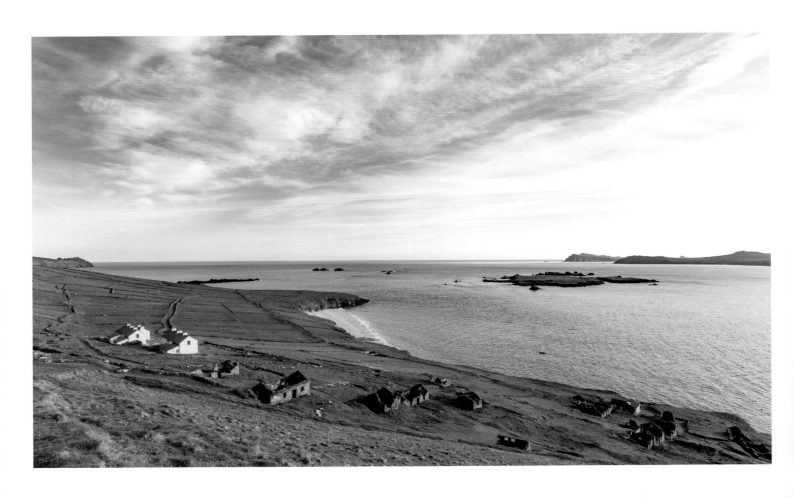

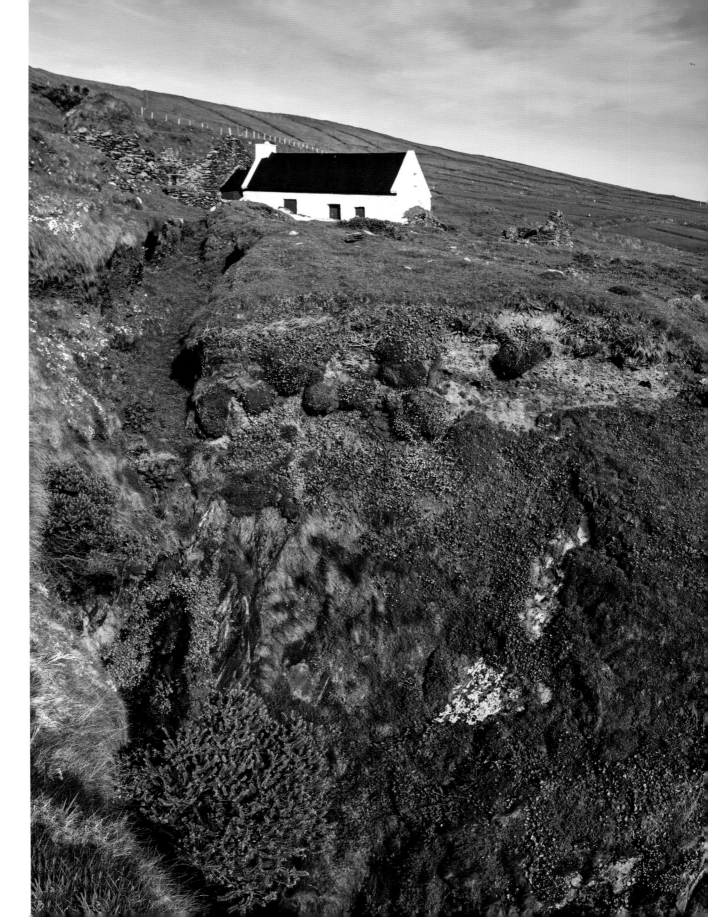

The view from Peig Sayers' house on the Great Blasket. It is widely believed that the Blasket Islands produced more writers per head of population than anywhere else in the world. In the early part of the twentieth century, from 150 or so inhabitants, three writers emerged, all writing in their native Irish: Tomás O'Crohan (*The Islandman*, 1929); Muiris O'Sullivan (*Twenty Years a-Growing*, 1933) and Peig Sayers (*Peig*, 1936). Sayers' book is part of the curriculum in Irish schools. Drawing on their austere way of life, ancient traditions and cultures, these writers produced frank, fascinating accounts of their experiences and memories. These books are full of wit, wisdom and charm about a people living a remote life on the edge of Europe and recount the fishing, farming and relationships on the Blaskets, while looking out at the changing world on the mainland across the narrow strait.

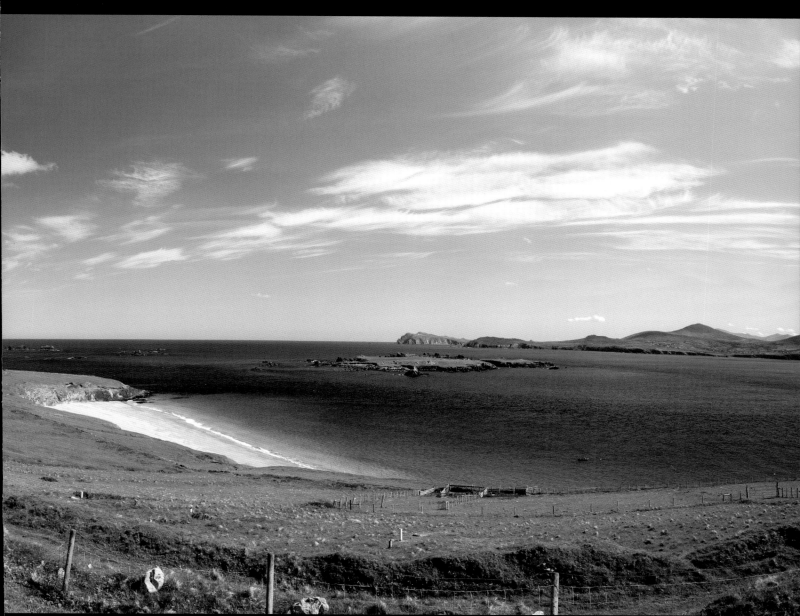

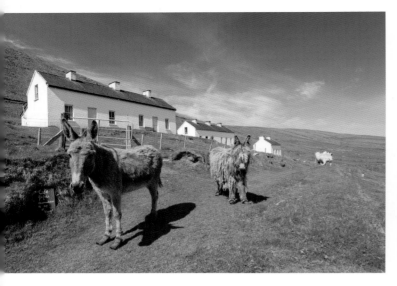

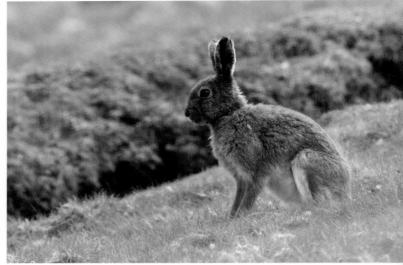

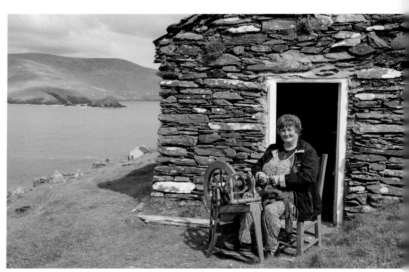

Top left: Peig Sayers' house is now also a summertime hostel. True to traditional Blasket life, there are few home comforts as there's no electricity, and there's only an outside loo. But there are candles for light and storytelling in the evening, so a stay here comes with an authentic experience guaranteed.

Top right: Blasket hare.

Left: Navelwort is found on cliffs, in rock faces and on stone walls throughout the county. It was known to be a cure for corns.

Above: Sue Redican at her spinning wheel. Sue has been working her weaving skills on the Great Blasket for over thirty years.

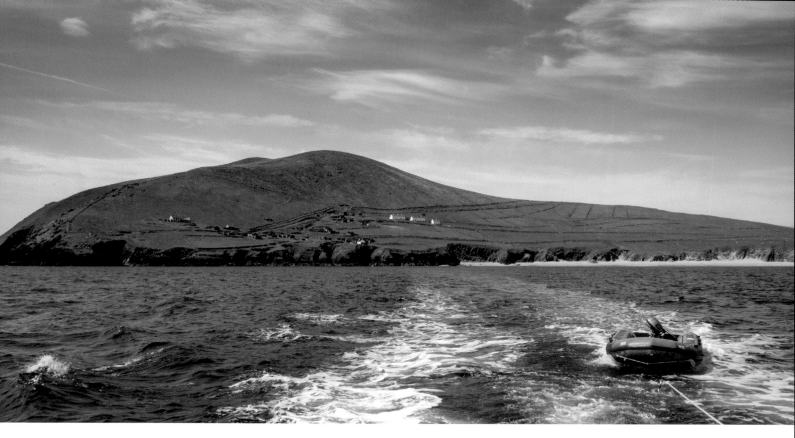

Above: Blasket wake.

Below: Sunset over what is known as 'The Sleeping Giant', the island of Inishtooskert; the northernmost of the Blasket Islands. The silhouette of the island, from the mainland, looks like a man lying on his back.

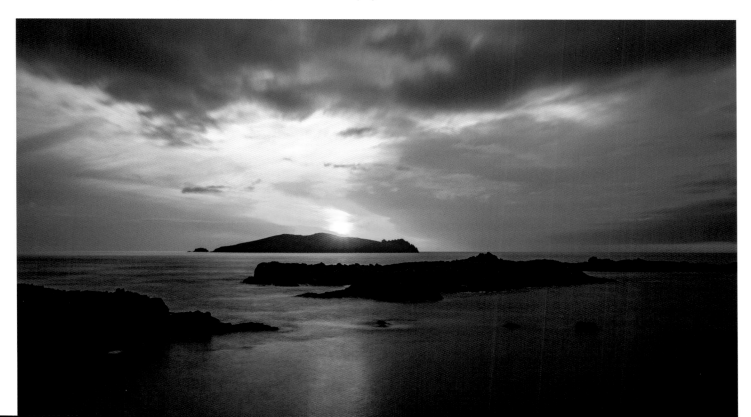

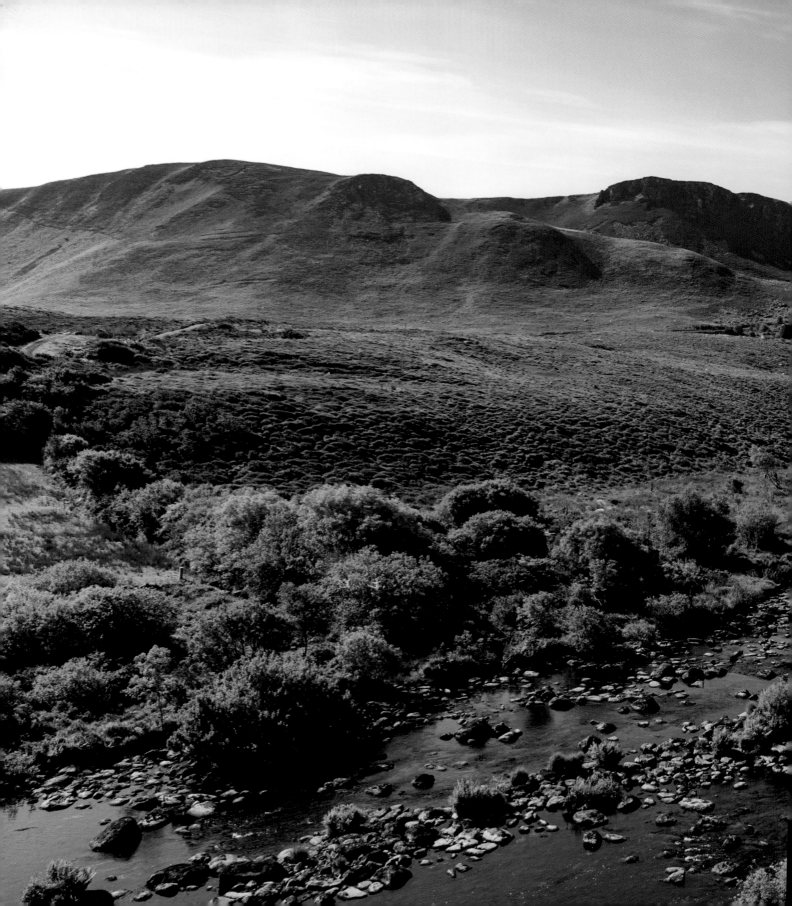

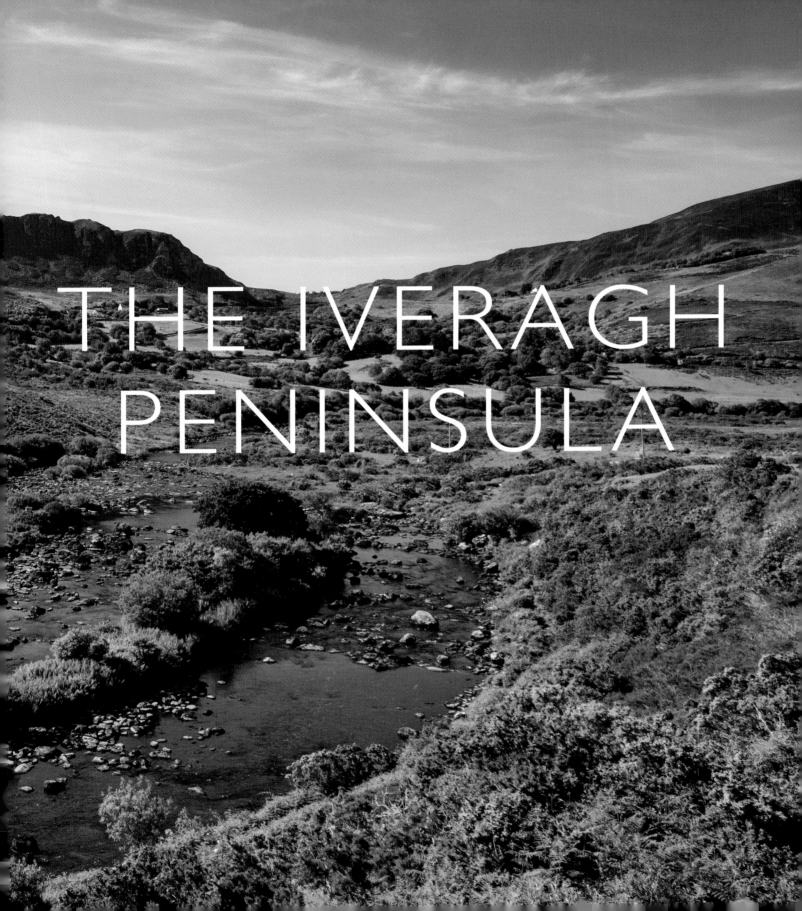

THE IVERAGH PENINSULA

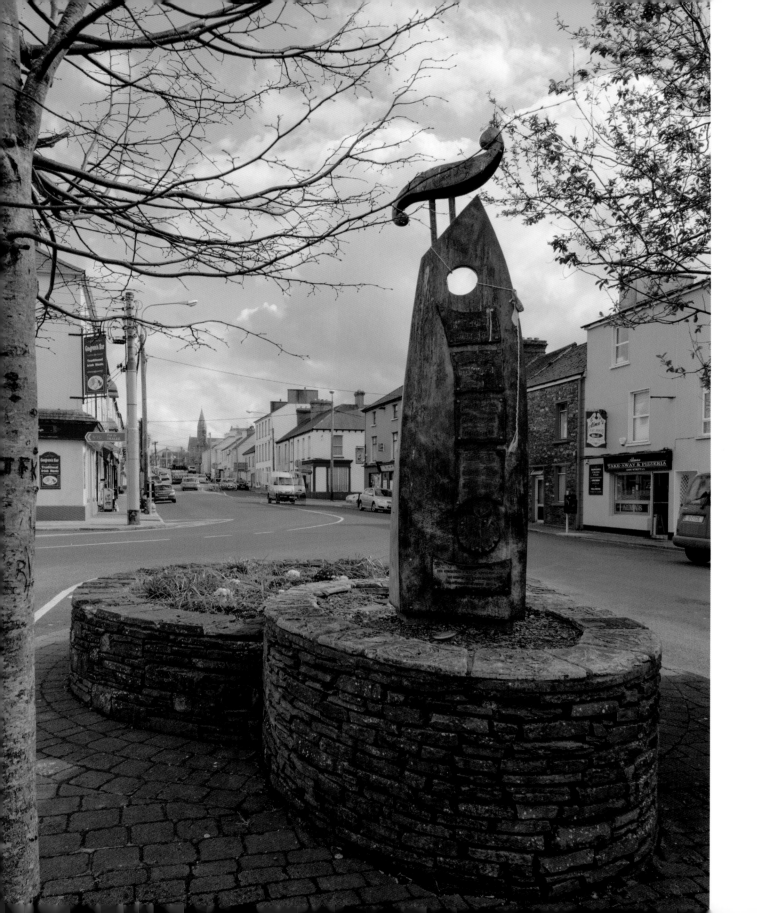

THE SOUTH-WEST PART OF THE COUNTY IS KNOWN as the Iveragh Peninsula, and it is here that the famous Ring of Kerry is found. Killorglin, Cahersiveen, Portmagee, Ballinskelligs, Waterville, Caherdaniel, Sneem and Kenmare all enjoy the mild climate conveyed by their close proximity to the Gulf Stream. Scattered throughout the peninsula's wilderness is a wealth of rivers, lakes, beaches, subtropical vegetation and wildlife.

MILLTOWN

Opposite: Milltown.

Below: Many people drive straight through Milltown; however, it is well worth a stop, if only to see the Organic Shop, Siobhan within and her border collie guarding the produce outside.

Previous page: River Caragh, near Dooks.

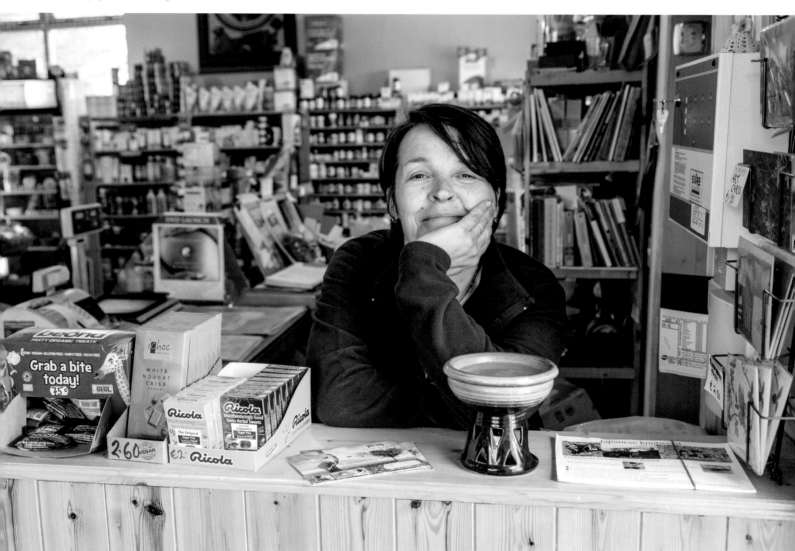

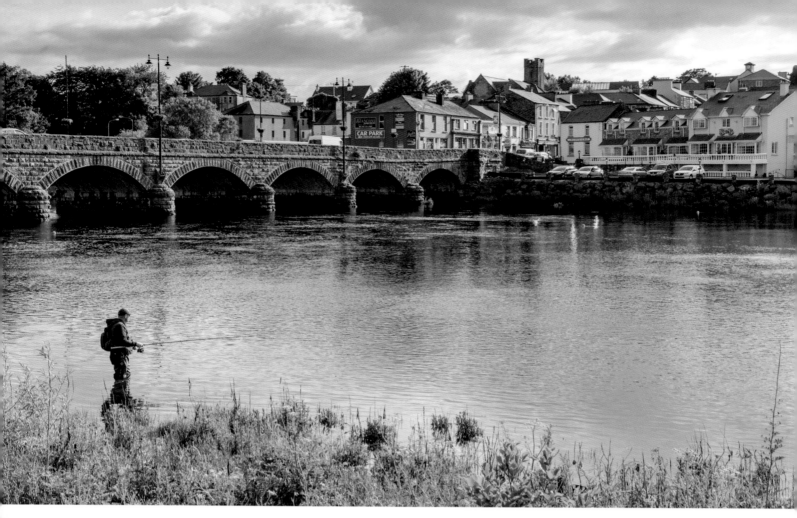

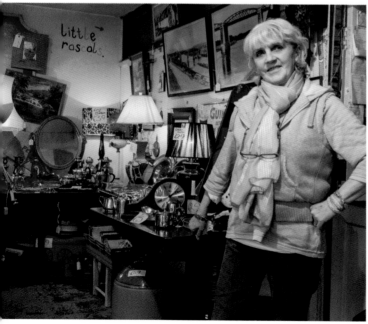

KILLORGLIN

Above: Fly-fisherman on the river Laune, Killorglin.

Left: Mary, Killorglin Antiques.

Opposite: Sculpture of King Puck, Killorglin. Summer brings with it many festivals, regattas, horse races, shows and more. The most famous of these, and certainly Ireland's oldest, is Killorglin's Puck Fair, held in mid-August each year and described as the king of festivals. Each year a wild mountain goat, the finest specimen available, is brought down from the mountains and crowned king – yes, king. For three days he is held aloft in a cage while the festival goers act the 'goat' below. It sounds a little mad, and, truth be known . . . it is! Mayhem, magic and madness prevail, and the pubs stay open until three in the morning. Listen out for someone quite rightly saying 'only in Kerry'. The very best entertainment is laid on throughout the town, and it is all free, so things are not entirely crazy. If your visit coincides, do go along. There is a saying, 'It's better to regret something you have done than not do it!'

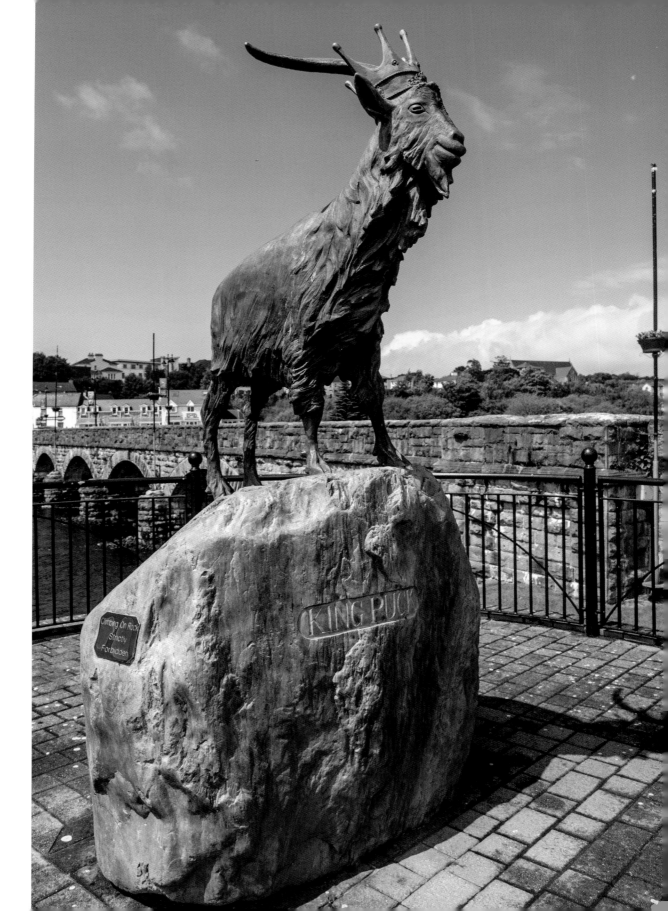

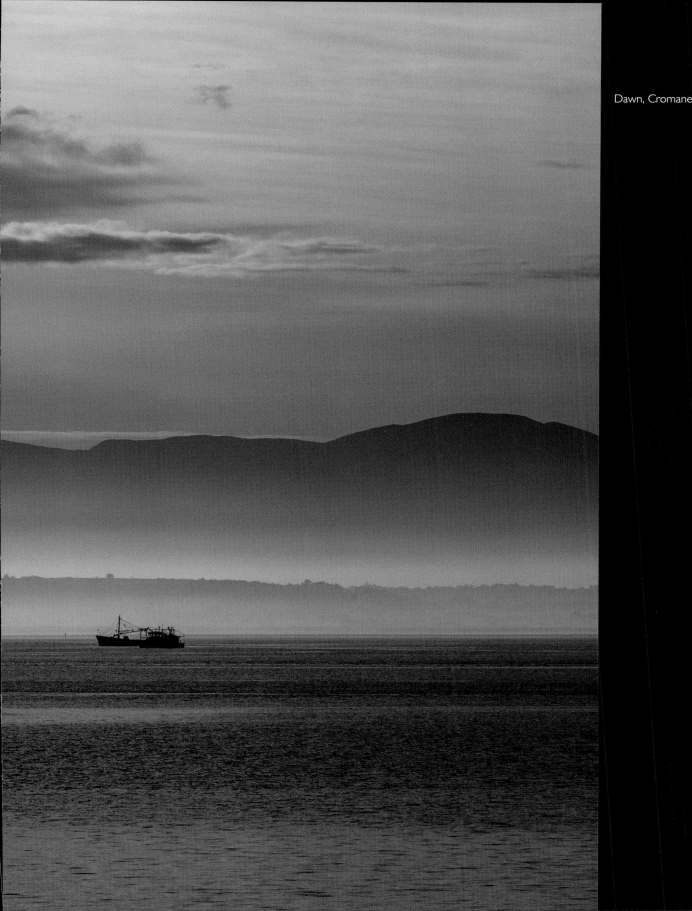

Dawn, Cromane

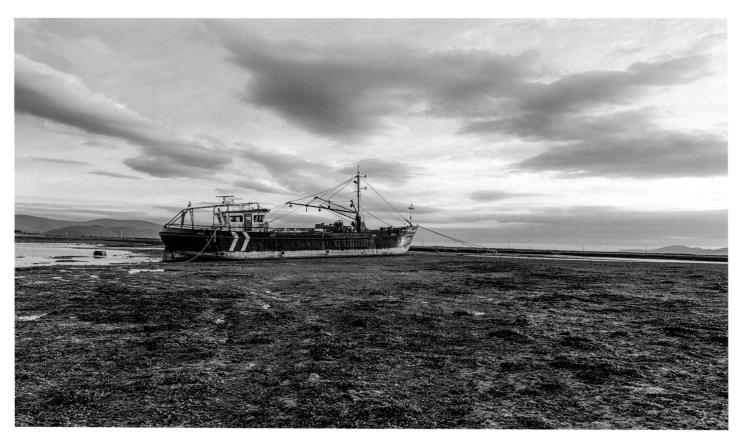

CROMANE

Above: The sheltered waters off Cromane at the head of Dingle Bay and Castlemaine Harbour are home to the local shellfishing industry. Look out for Cromane mussels on the menu when dining out.

GLENBEIGH

Below: Glenbeigh is an excellent base from which to explore the area, particularly the beautiful, atmospheric Rossbeigh Strand.

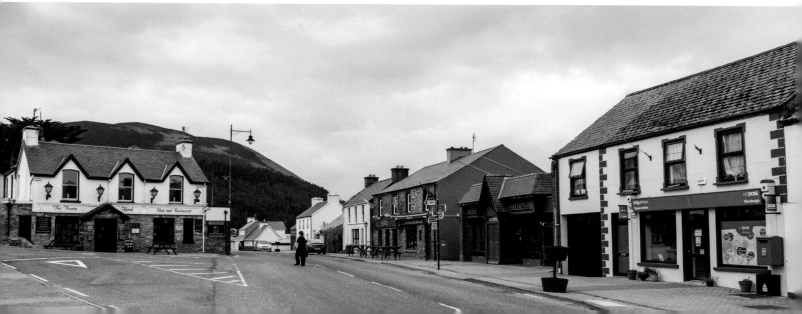

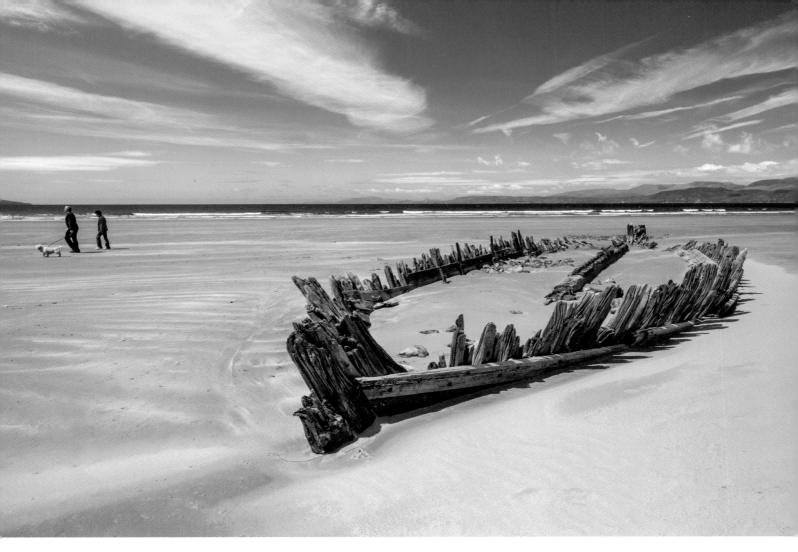

ROSSBEIGH

Above: *The Sunbeam*, as seen before the 2014 storms. In January 1903, whilst navigating Dingle Bay and en route from Kinvara to Cork, a 79-foot schooner called *Sunbeam* was driven towards the shore in bad weather and ran aground on Rossbeigh strand. The wreck lay where the ship had foundered for 110 years, submerged by the tide twice daily, until January 2014 when severe weather battered the west coast of Ireland, sadly destroying its photogenic looks for ever. About a mile or so along the strand from the village, it provides a convenient turning point for local joggers and dog walkers.

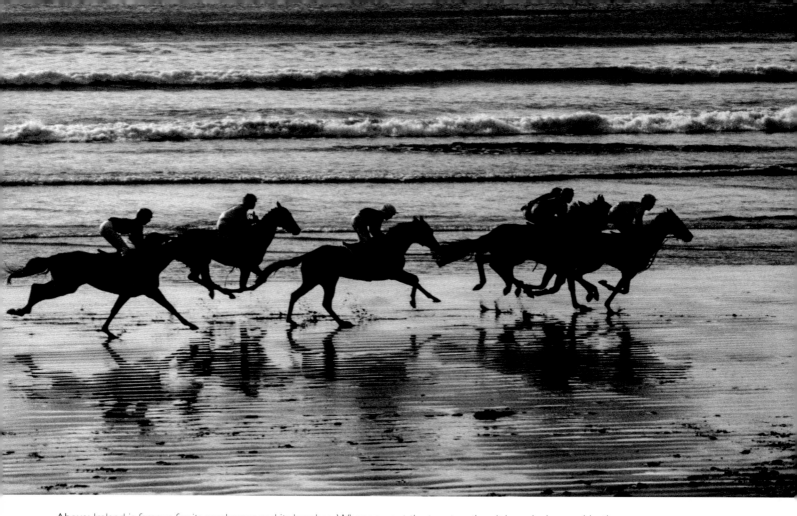

Above: Ireland is famous for its racehorses and its beaches. When you put the two together, it is a winning combination. Riders and their mounts thundering along Rossbeigh beach, with Dingle Bay and the setting sun in the background, a sight to remember.

Opposite top: Photographers record another Rossbeigh sunset – and add a little extra interest to mine.

Opposite bottom: The Great Southern and Western Railway (GS&WR) ran from Farranfore to Reenard Point in Valentia Harbour from 1893 until its closure in 1960. Much of the railway bed, bridges, piers and crossings are still in place, so be sure to look out for these historic structures as you pass through this part of the county. This route includes Caragh Lake and Mountain Stage above Kells Bay, making it possibly the most scenic line in all of Europe. Locally, people still speak very fondly of the railway line and of 'going up to Dublin' on the train. Unusually, on the line's closure, the running stock (carriages) were still the originals from the 1890s. Fortunately, funding is now in place to make a 'green-way' cycle track of the line, opening up once again this beautiful route into the county.

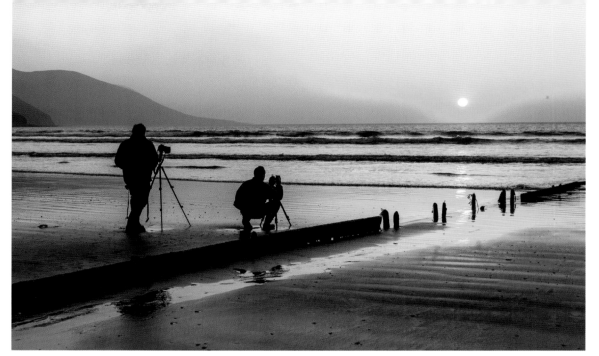

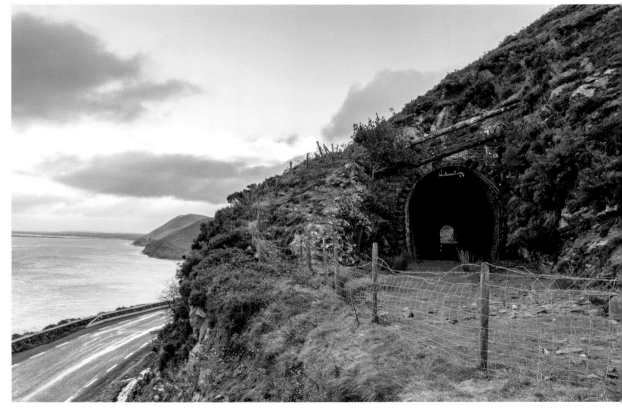

KELLS BAY

Below: Kells Bay.

Opposite top left: Gunnera plants, taller than a person! Kells Bay Gardens have been open to visitors since 2008 and are well worth a visit. They contain a fine selection of subtropical New World plants and trees.

Opposite top right: Ireland's largest palm tree.

Opposite bottom: Low cloud over Knocknadobar, on the road to Cahersiveen.

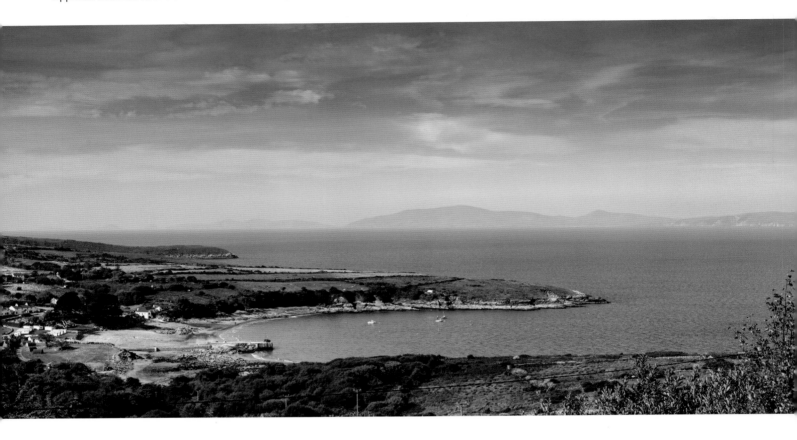

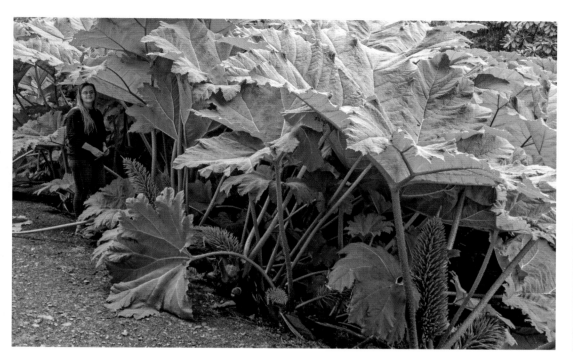

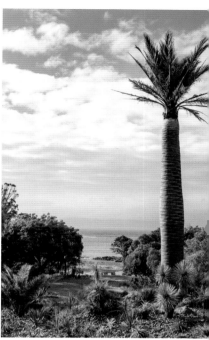

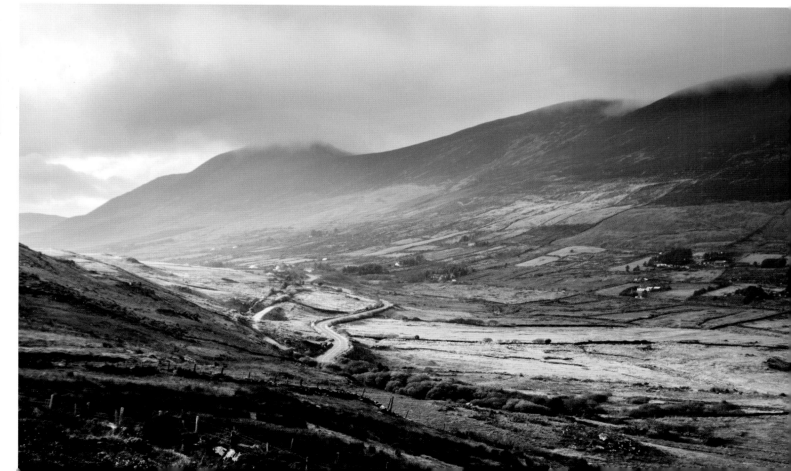

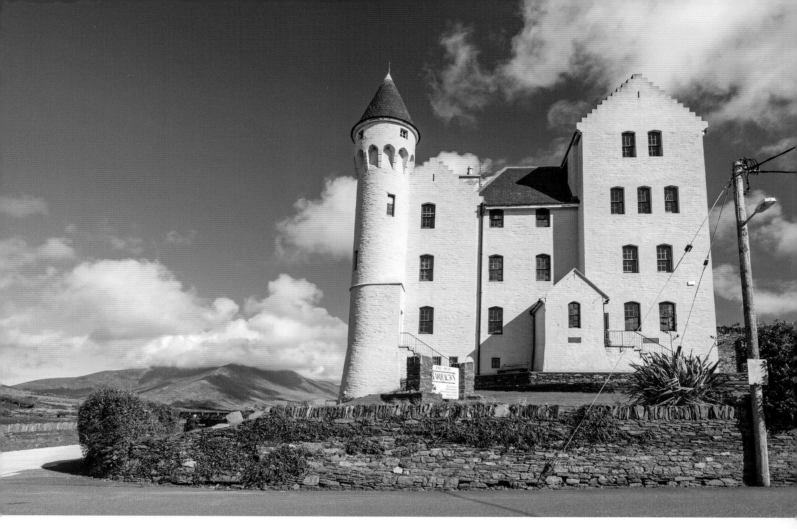

CAHERSIVEEN

As with many places in Kerry, there are various spellings of the name *Cahersiveen*, so don't get too hung up on any one. The meaning of the name is 'Little Sadhbh's stone ringfort', and there are two possible candidates close by. If you are travelling along the Wild Atlantic Way or 'The Ring', you will pass through Cahersiveen. It is well worth making the time to stop and look around. The church, named after local and national hero Daniel O'Connell ('The Liberator'), is large and impressive, given the size of the town it serves.

Above: Standing tall above the river Fertha is the old police station, or barracks, which is now the local heritage centre.

Left: Cahergall Stone Fort.

Right: Ballycarbery Castle.

Below: Sunrise over the river Fertha.

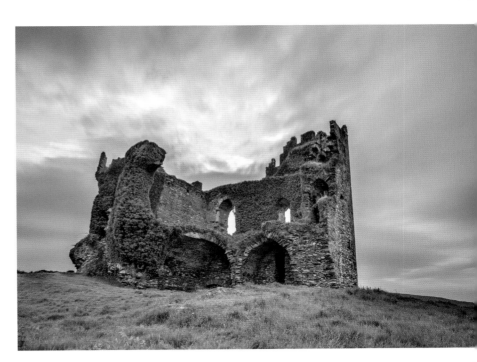

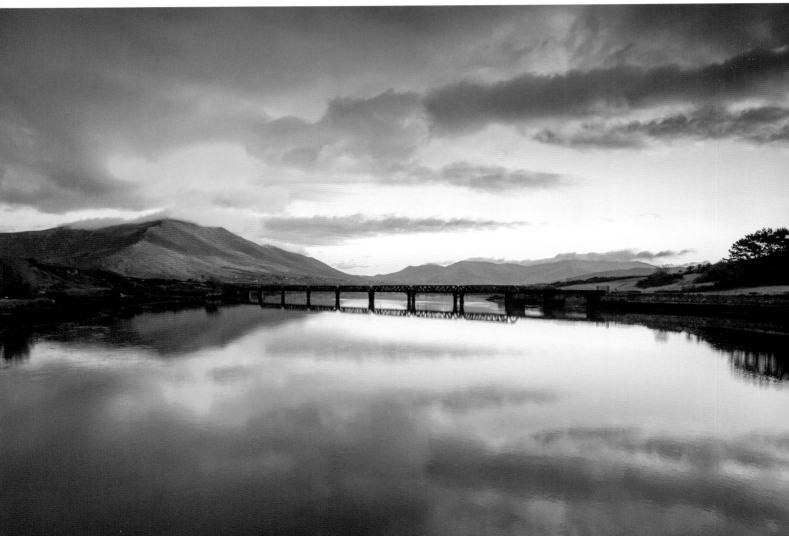

PORTMAGEE

Below: A still summer's evening, Portmagee. Portmagee is a pocket-sized place and yet the jewel in the crown of the kingdom of south-west Kerry. The heart of the village is its harbour, the setting-off point for trips to the Skelligs. The village gained its name from Captain Theobald Magee. Magee obtained a reputation as a 'pirate' by bolstering his legitimate business as a shipping merchant with a 'little smuggling' – brandy, whiskey, tea, etc. The broken coastline here would have provided many perfect hiding places to haul contraband ashore without being seen by the customs and excise men.

Opposite: A small sailing boat at its mooring, on a flat calm sea. A period of high pressure can lead to days of such settled weather. On this occasion, the image was captured during a couple of glorious 'breathless' weeks in mid-September. Sometimes you just have to be there.

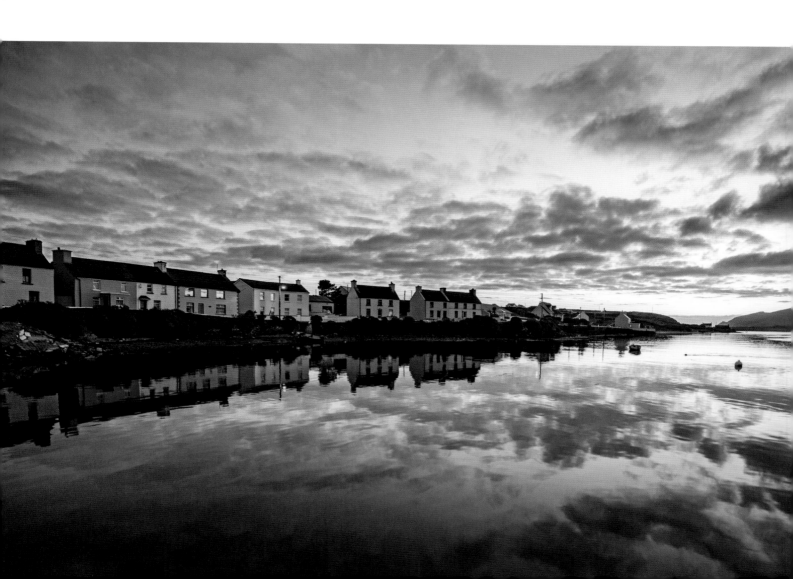

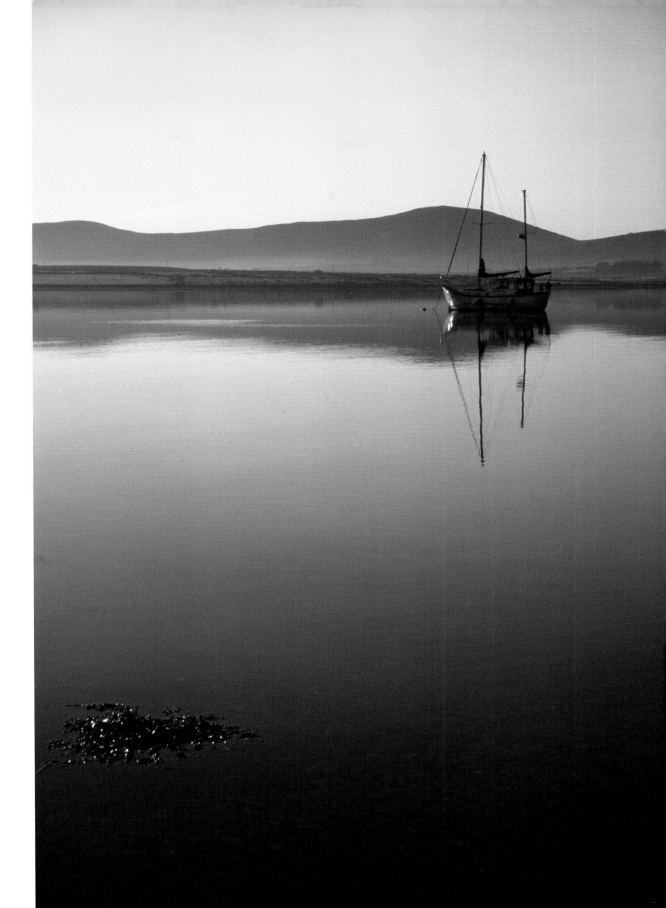

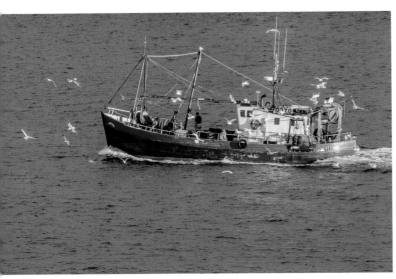

Left: Bringing home the catch.

Below: Portmagee Regatta racers put their backs into it. Seine boats are used for racing at the many regattas held around Kerry each summer. The boats were originally used for fishing, whereby two crews of eight to twelve men hauled a 'seine' net behind their boats. When the fish arrived inshore, the seine rowers would race to the shoals to secure the best catch.

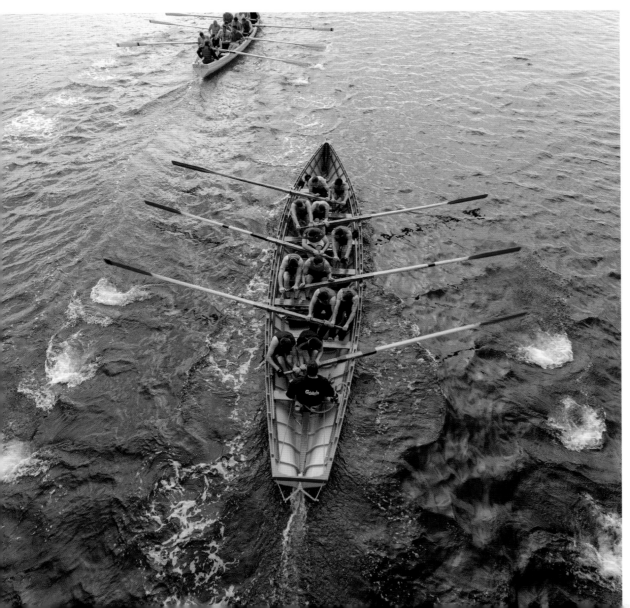

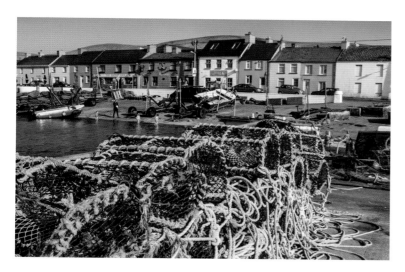

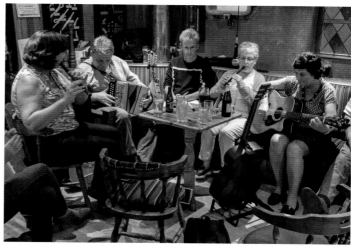

Above left: Portmagee Harbour lobster and crab pots.

Above right: The Bridge Bar in the centre of Portmagee is one of the liveliest hostelries in the kingdom. If you are hoping for some musical entertainment, the pub is the place. Usually music will start quite late, rarely before nine o'clock. Look out for posters or just a piece of paper in the window advertising live music. If it gives a start time you can generally add half an hour or so to it before the music begins. Throughout the summer months there is a lot of music, and you can be spoiled for choice. There are also a lot of impromptu 'sessions' – these are my favourite.

Bottom: The Skelligs seen from above Coomanaspic Pass.

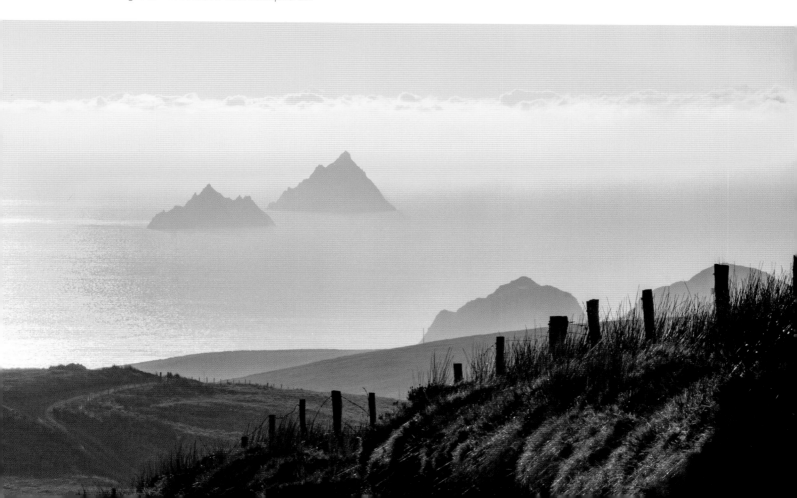

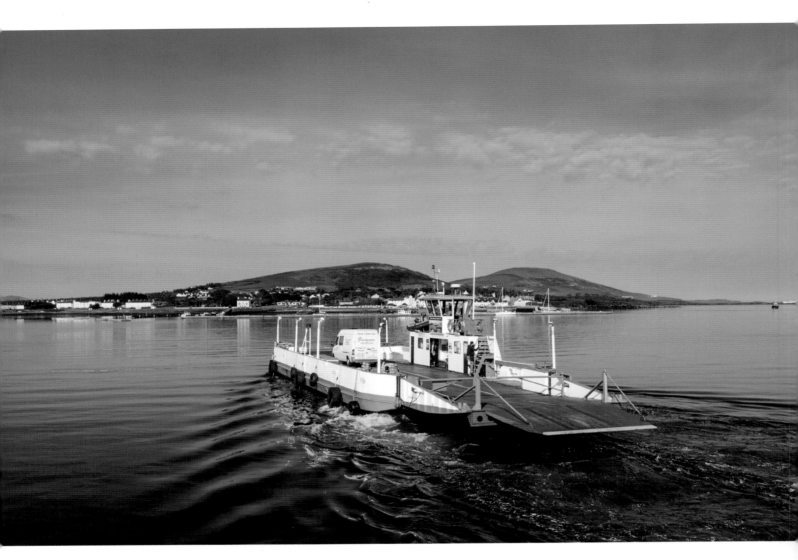

VALENTIA

Above: Valentia island sits on the south side of Dingle Bay. Eleven kilometres long by three wide, Valentia has been linked to the mainland now since the 1970s and is technically no longer an island, but don't say that to the locals. A small car ferry runs from Reenard Point near Cahersiveen to Knightstown during the summer.

Below: Dawn, looking east from Valentia bridge along Portmagee channel. The navigational markers in the centre locate the submerged rocks known as the 'Portmagee Perches'. At low tide these rocks are popular resting places for the local grey seals. This part of the world is famous for its glorious sunsets; however, few get to see a sunrise, especially in June when a 5 a.m. start would be necessary. If it coincides with some calm weather, the reflections on the water can make the spectacle even better.

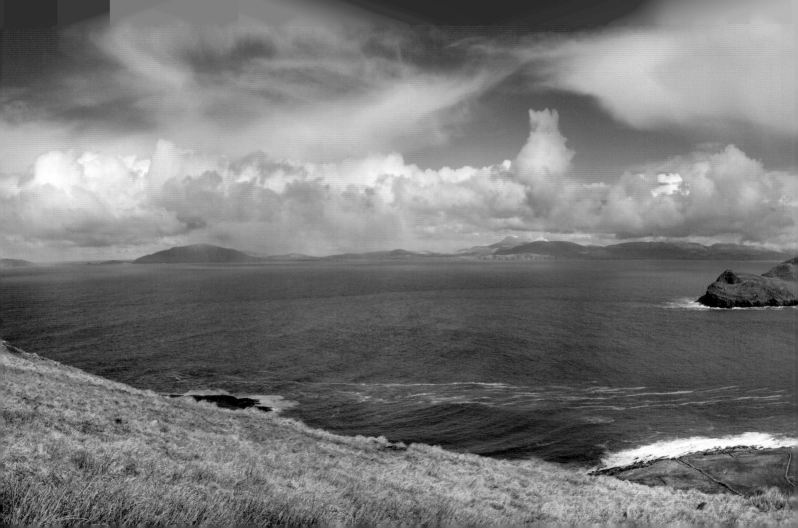

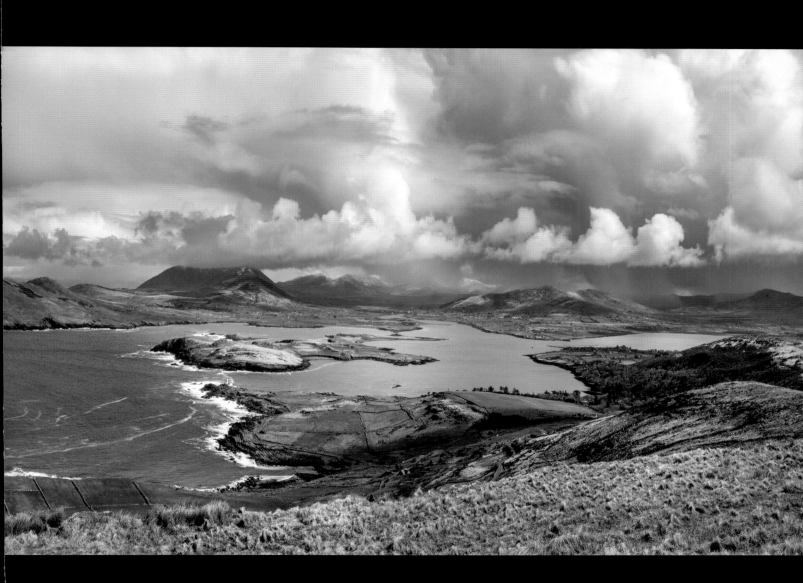

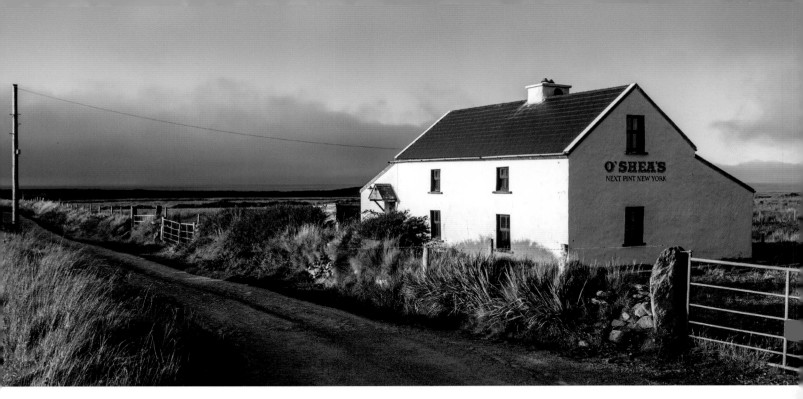

Above: O'Shea's near Culloo, Valentia, painted up to look like a pub and used in the Guinness TV advert 'San Jose'. The writing on the wall reads 'Next pint, New York'.

Right: Bog cotton is a native plant of the western coast of the British Isles. As the name suggests, it is found in acidic wetlands: bogs. It can also be a good warning of dangerous conditions: some bogs are rather deep and treacherous, so walkers beware! Flowering in June and reaching from twenty to seventy centimetres in height, an intense growth of bog cotton can, from a distance, look like a late covering of snow.

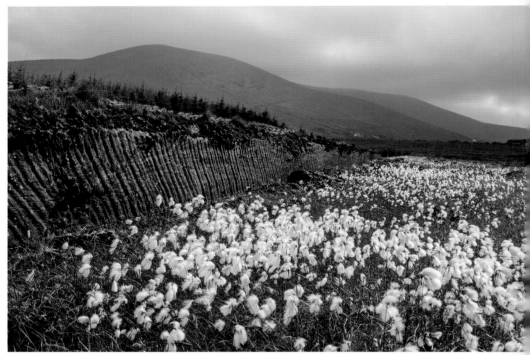

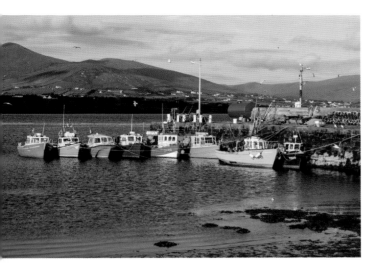

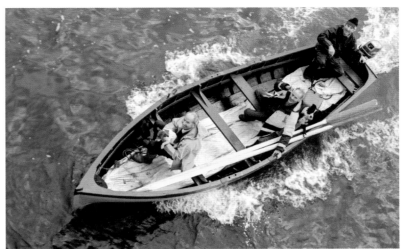

Above left: Knightstown.

Above right: Three local men (Willy, Christy and Dennis) return home from an afternoon out in Portmagee.

Below: Grey heron in the evening light, looking, waiting, for an opportunity.

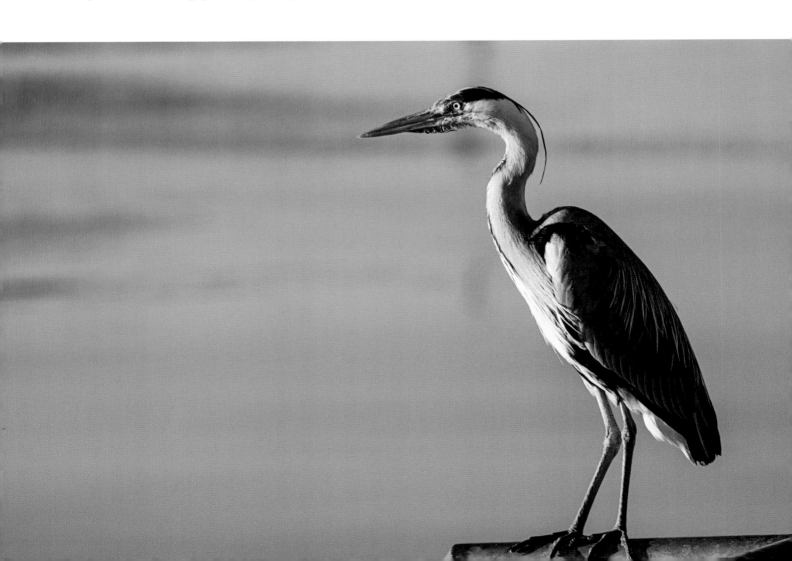

Below left: Valentia Harbour Station memorial, Reenard Point. The station is long gone; there is now a fish factory on the site.

Below right: Great Southern & Western railway viaduct, Glensk.

Bottom left: In 1858, the first transatlantic cable communication between Valentia and Heart's Content, Canada, was made. The cable station in Knightstown closed in 1966.

Bottom right: At nearly 4 million years of age, the Valentia Island tetrapod trackway is the longest and oldest on earth. One of only four known trackways in the world, it marks the point when animals first made the transition from sea to land and shows a turning point in evolution. Recognised by a geology student in the early 1990s (though known about by the locals for much longer), the trackway is now open to visitors.

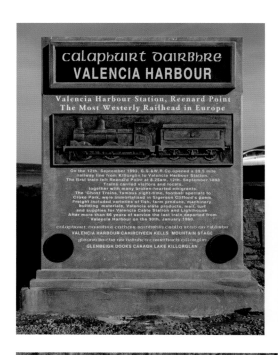

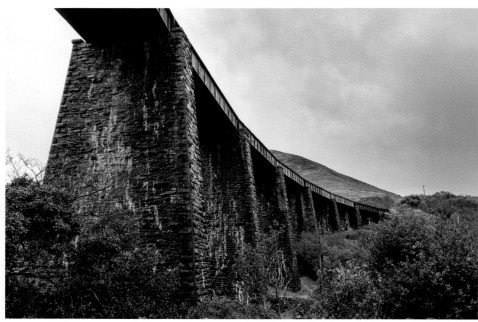

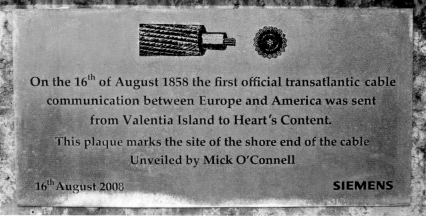

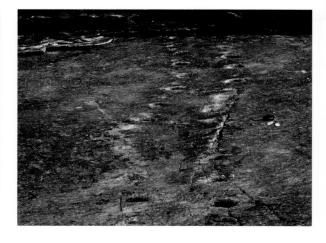

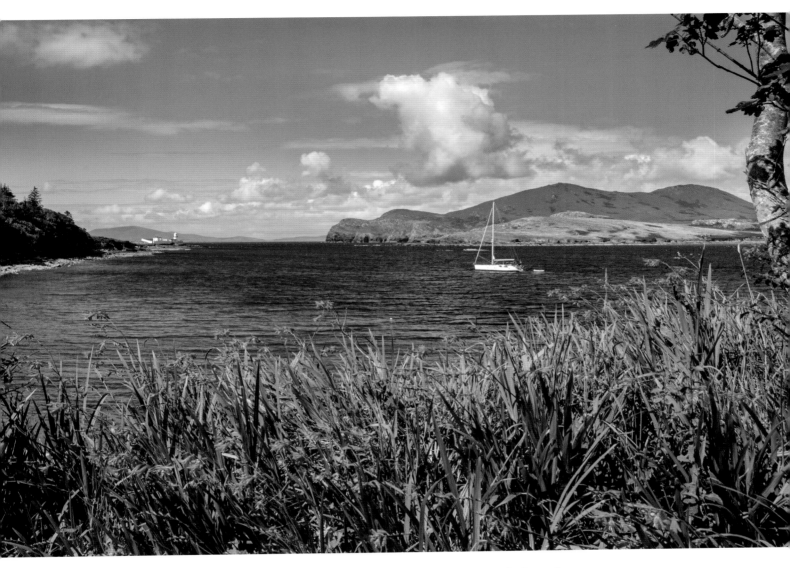

Above: The infamous Kerry rain that keeps the countryside so green also provides an abundance of colour – from the iconic bog cotton and sea thrift to the mile upon mile of fuchsia and montbretia that line the lanes each summer. Montbretia originally came from Africa, and the hybridised plants we see in Kerry are extremely invasive and almost impossible to control once established. A hot spell in summer followed by a strong downpour brings them into bloom.

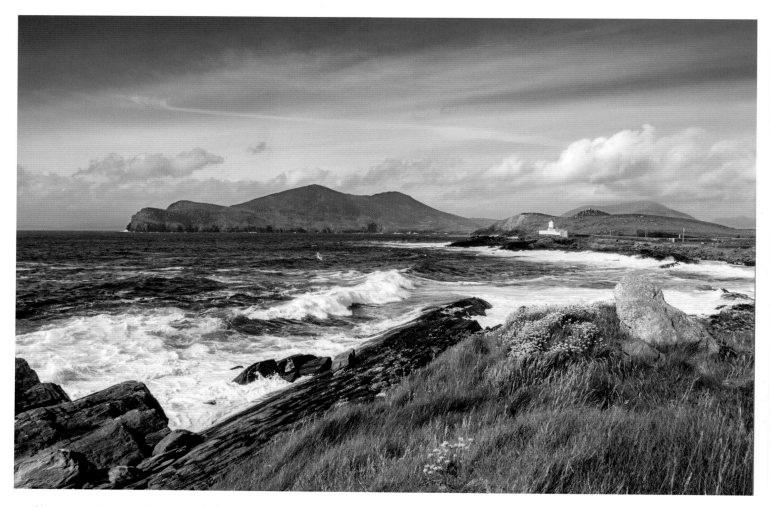

Above: Since the early 1840s, the light from Valentia Lighthouse has guided vessels into Valentia Harbour, and it is still functioning nearly 180 years later. Built on the site of a sixteenth-century Cromwellian fort (some of the defensive cannon can still be seen), it is now open to the public. Photographed on a summer's day, it looks picture-book perfect.

Opposite top: This promontory takes a severe lashing during storms. However, even on a fine day the unwary who venture too close to the water's edge can be swept from the rocks by the Atlantic swell.

Opposite bottom: Skellig sunset.

Overleaf: The Milky Way 'core' over the channel, Valentia. The Milky Way is visible during the summer months (May to August) in the Northern Hemisphere. Clear skies have to coincide with a moonless night to see it at its best. The area of the peninsula centred on Waterville has been designated the Kerry International Dark-Sky Reserve and is the only such reserve in the Northern Hemisphere – quite an accolade. All new lighting in the area now has to be 'dark-sky friendly', while existing sodium lighting, with its associated 'orange glow', is being phased out and replaced. The very faint streaks in the sky are meteors passing through the long camera exposure.

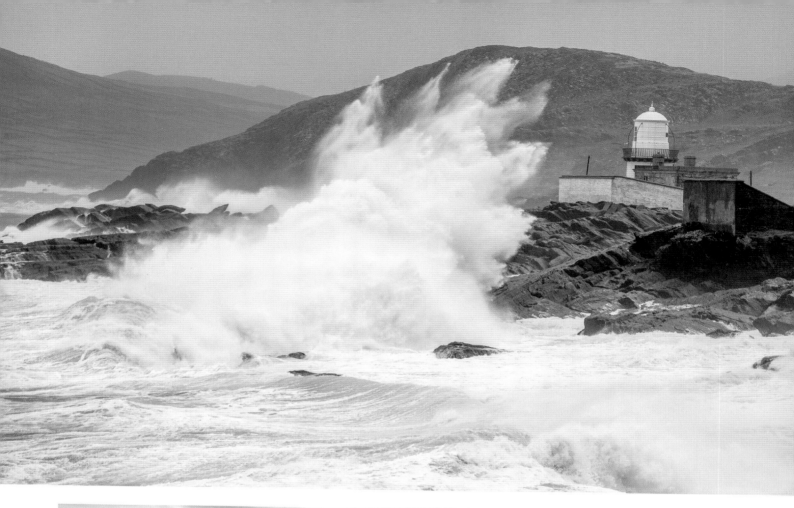
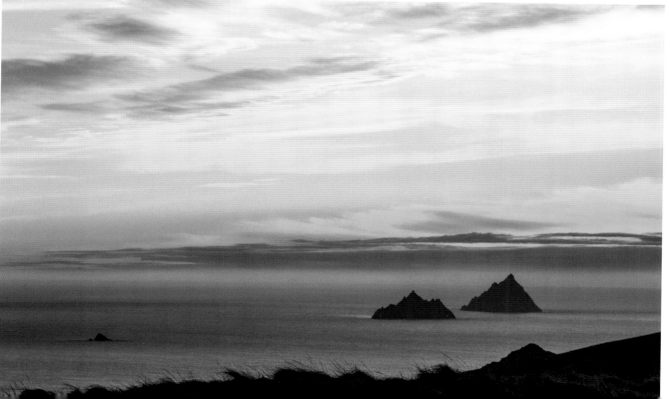

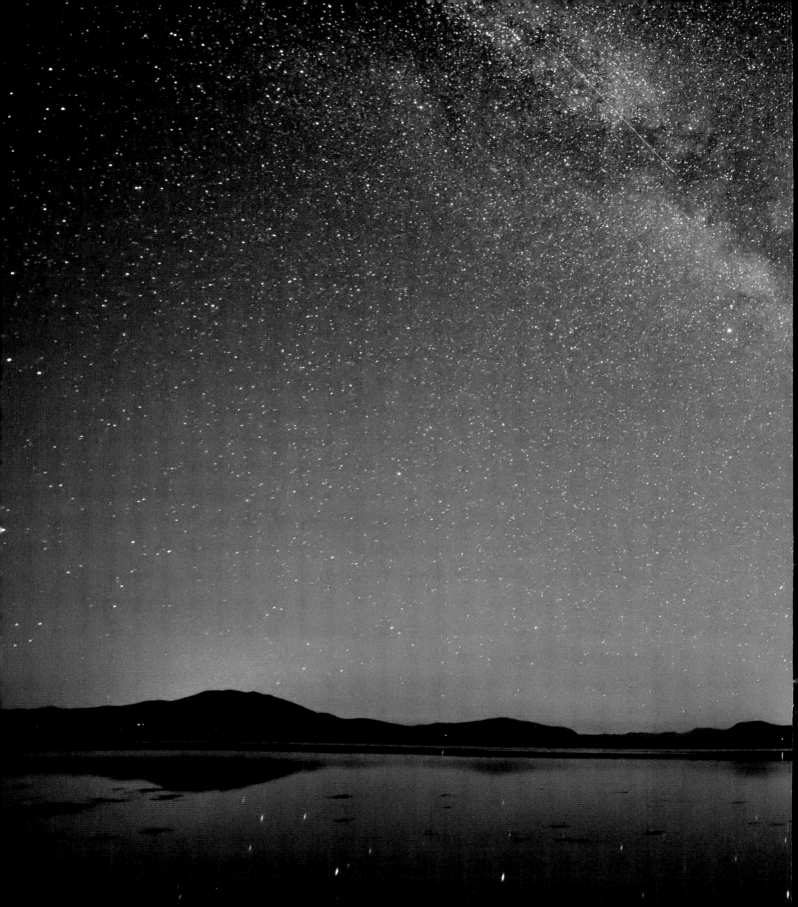

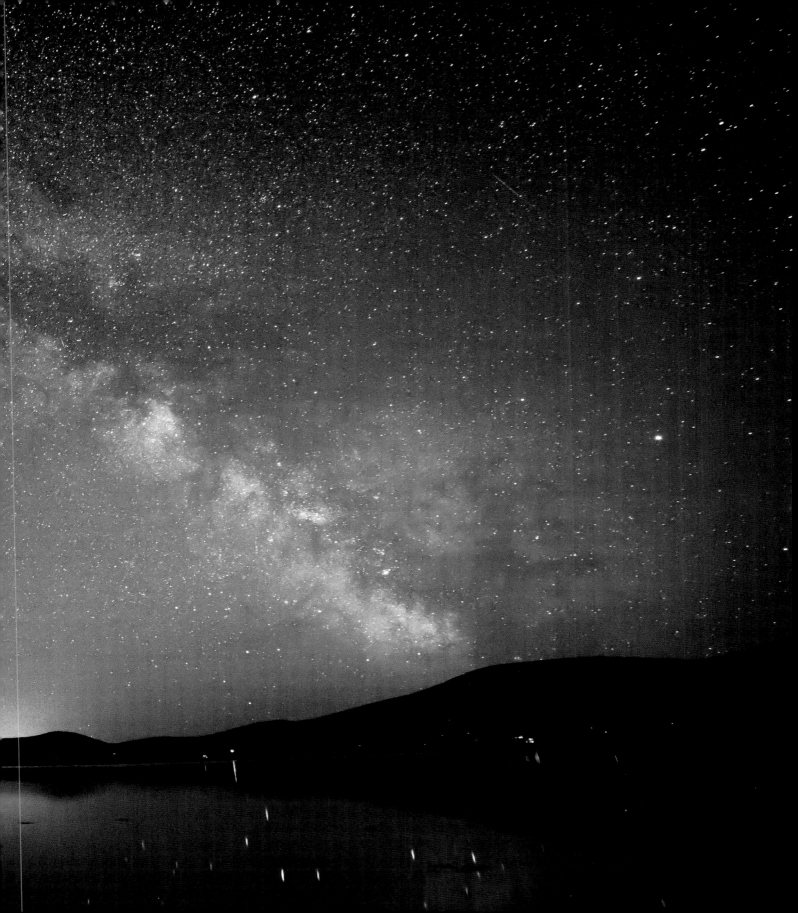

BALLINSKELLIGS

Below: Ballinskelligs and its Blue Flag beach.

Opposite top: One of a submerged forest of tree stumps on Reenroe Beach, Ballinskelligs, this root is occasionally visible after periods of exceptionally stormy weather when the sand is washed away from the beach.

Opposite bottom: Ewe, ewe and ewe . . . and ewe.

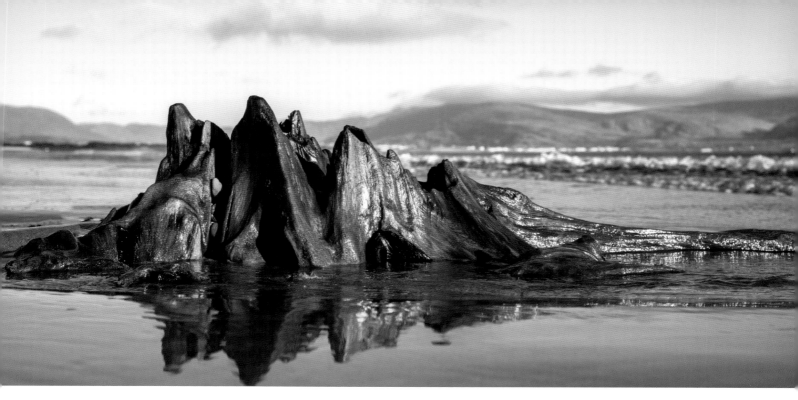

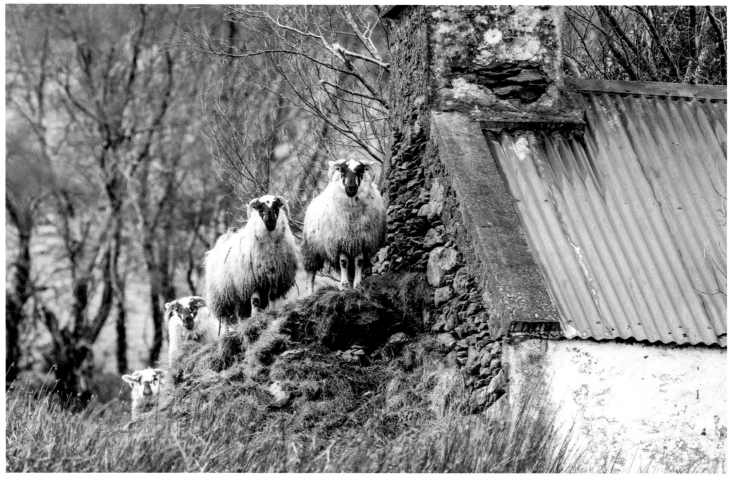

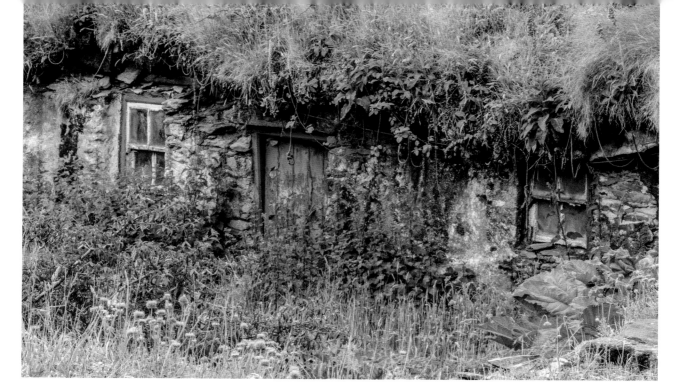

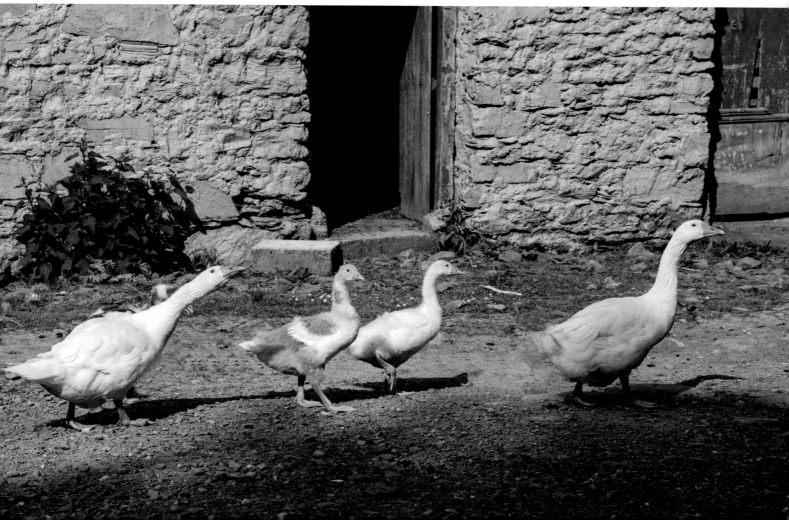

Opposite top: A friend remembers someone living in this old house near Ballinskelligs and smoke coming out of the door – there was no chimney! This was common with some of the very old cabins, where smoke would permeate up through the thatched roof.

Opposite bottom: Concerned parent geese escort their inquisitive young away from the dangers of the road.

Below: The Cill Rialaig Arts Centre in Ballinskelligs draws artists from around the world, to display their work and to create new pieces. The artists' retreat is set in an abandoned pre-Famine village, high on the cliffs and hundreds of feet above the crashing Atlantic waves – a place more dramatic and inspiring it is very hard to imagine. Artists can apply for a short-term residency, and many leave examples of their work for sale in the gallery. There is also a very nice café.

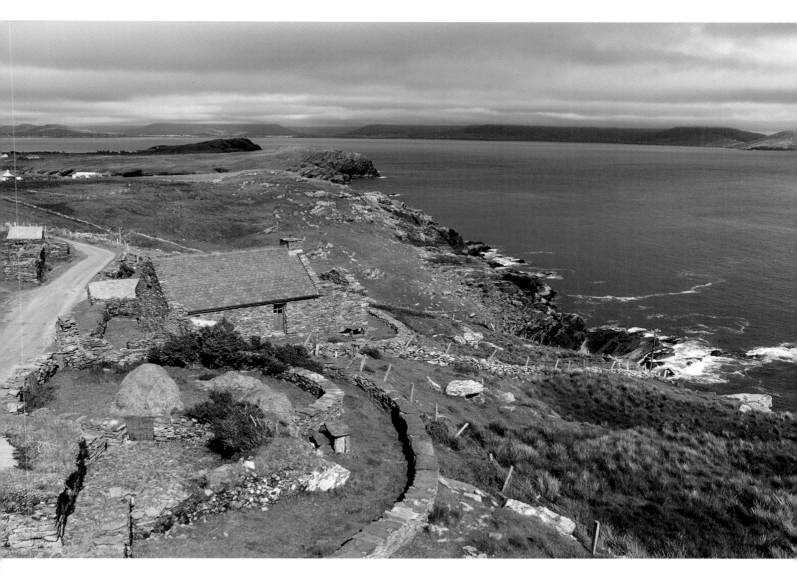

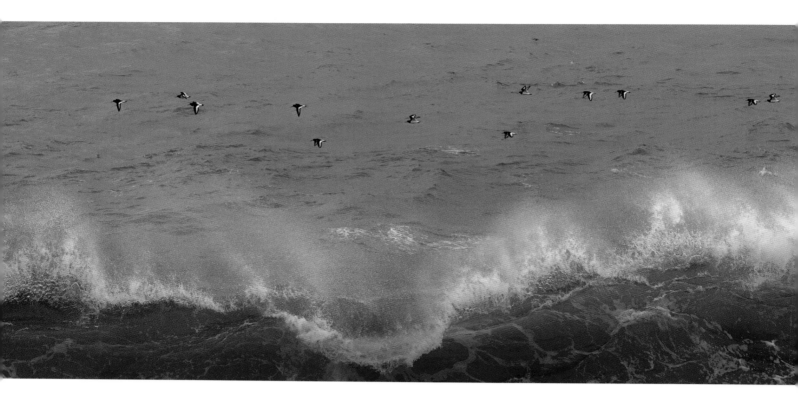

ST FINIAN'S BAY

Opposite top: Oyster catchers. The 'white horse' waves on the west coast of Ireland can be enormous, having had more than 3,000 miles of uninterrupted ocean in which to travel and grow. The prevailing westerly winds that propel them also result in this air being the purest in Europe, if not the world, thanks to the vast Atlantic Ocean between here and the eastern seaboard of America.

Opposite bottom: St Finian's Bay is a haven for surfers and body boarders. The waves can be fierce and the currents a challenge, so please take care.

Below: St Finian's graveyard.

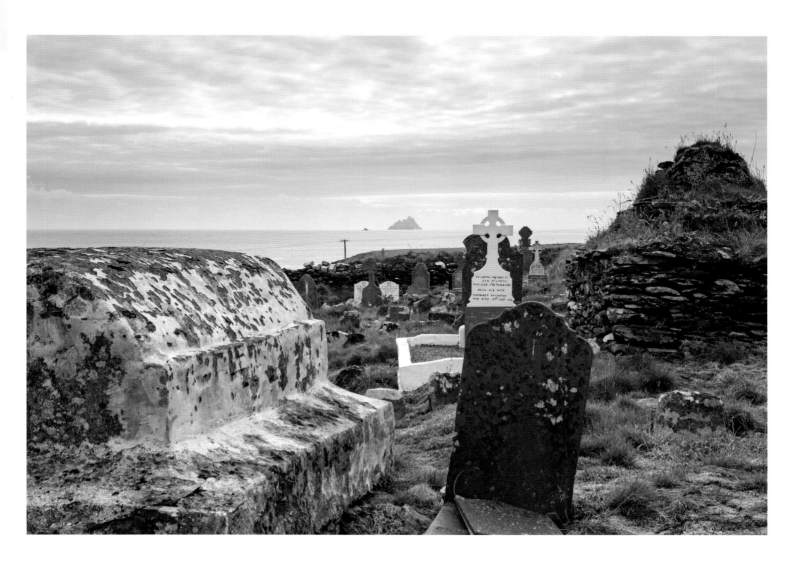

Atlantic breakers pound St Finian's Bay.

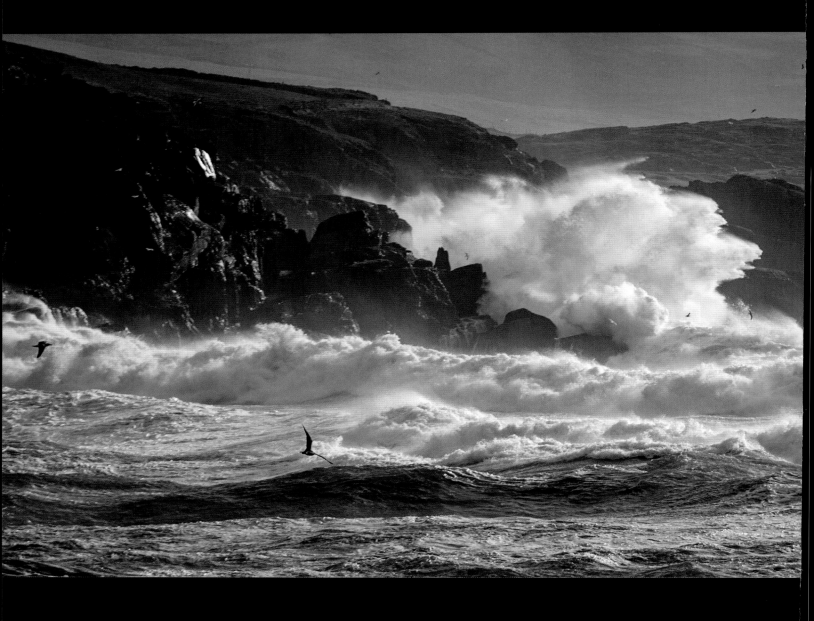

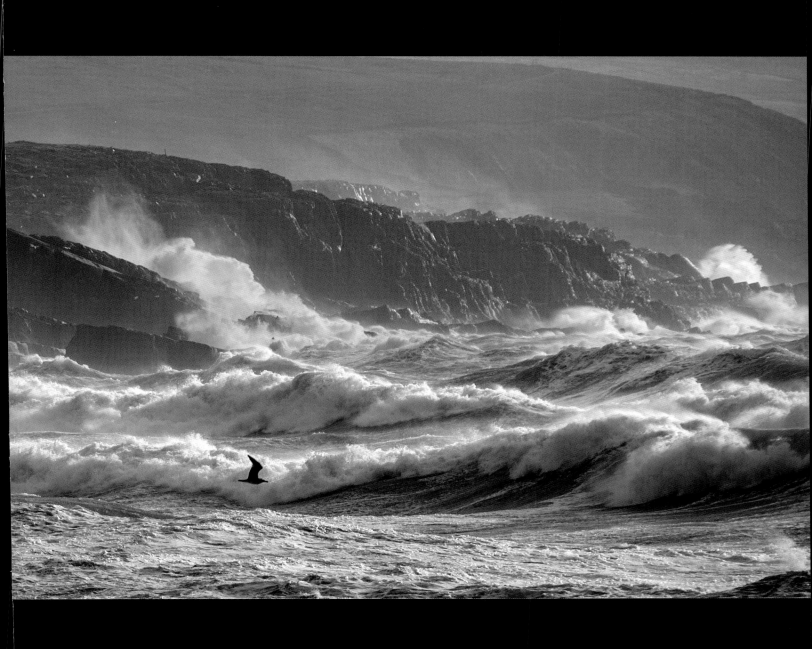

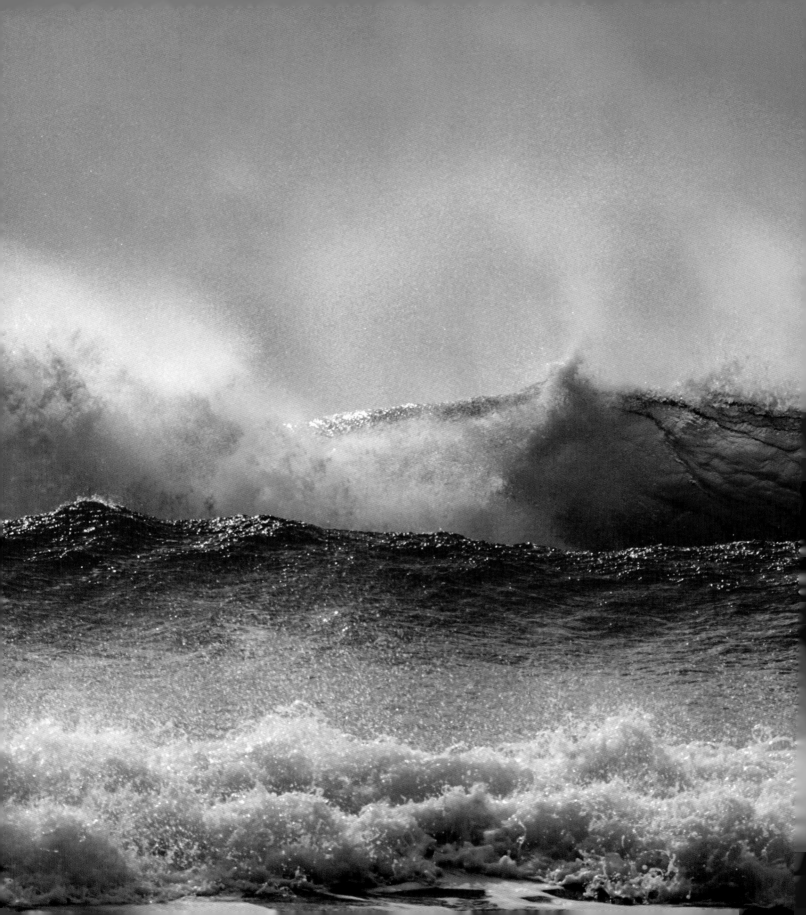

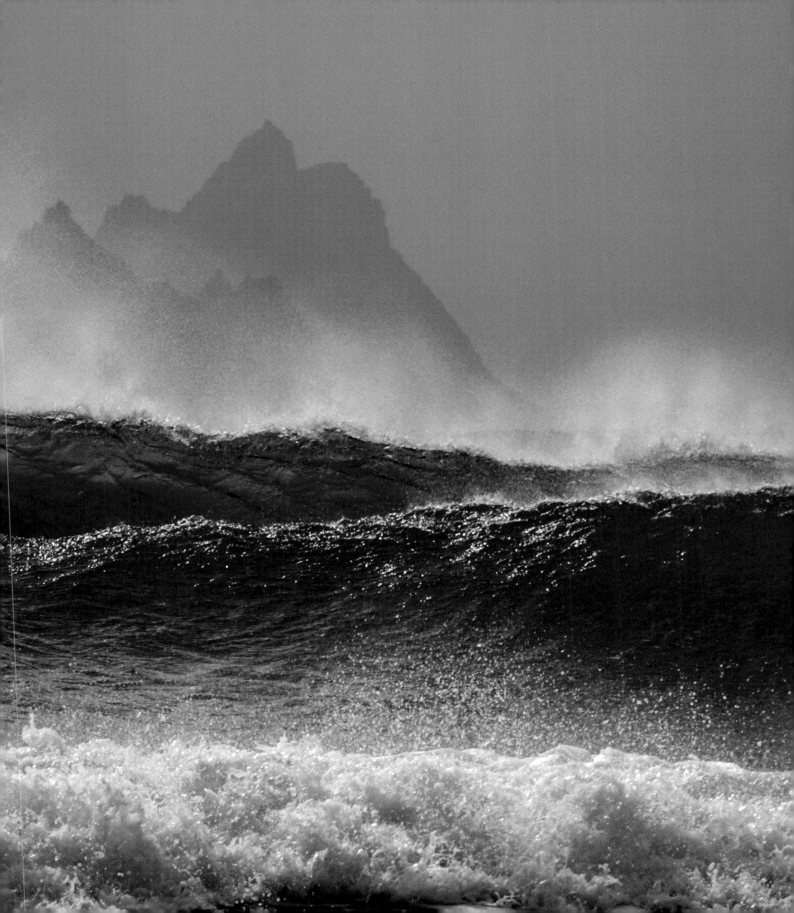

WATERVILLE

Below: Coomakista, Waterville. At approximately 2,500 kilometres, the Wild Atlantic Way traverses the full length of the west coast of Ireland, starting from the Inishowen Peninsula, County Antrim, in the north to the Old Head of Kinsale, County Cork, in the south. It enters Kerry at Tarbert, on the Shannon, and leaves just east of Kenmare. Opened in 2014, the route was always there; however, now with the new signage along the Way, there is no excuse for getting lost anymore.

Opposite: Eightercua Standing Stones.

Previous page: Skellig storm.

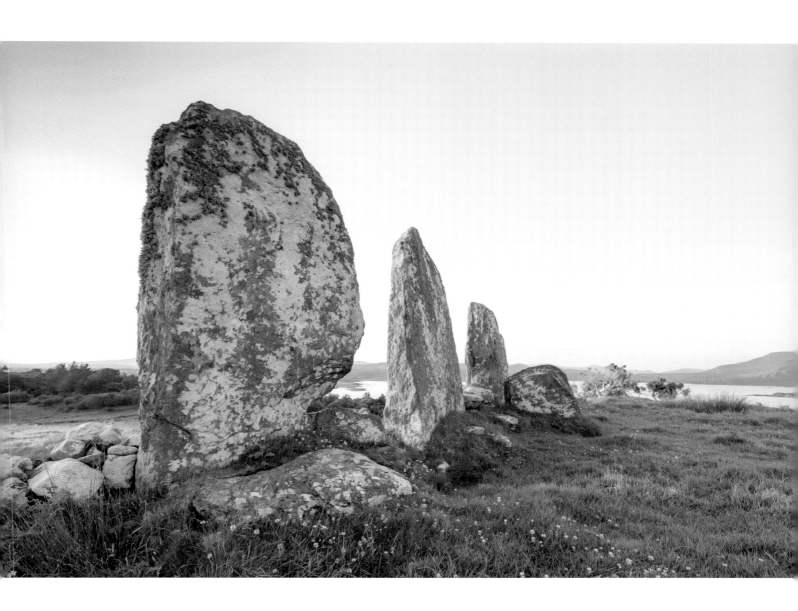

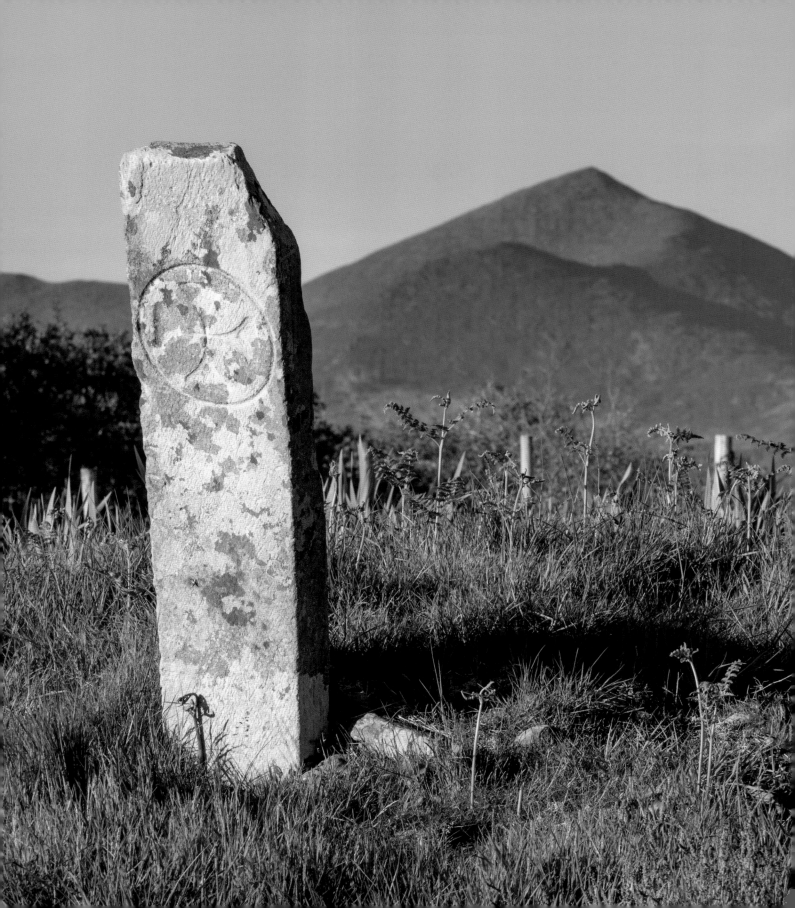

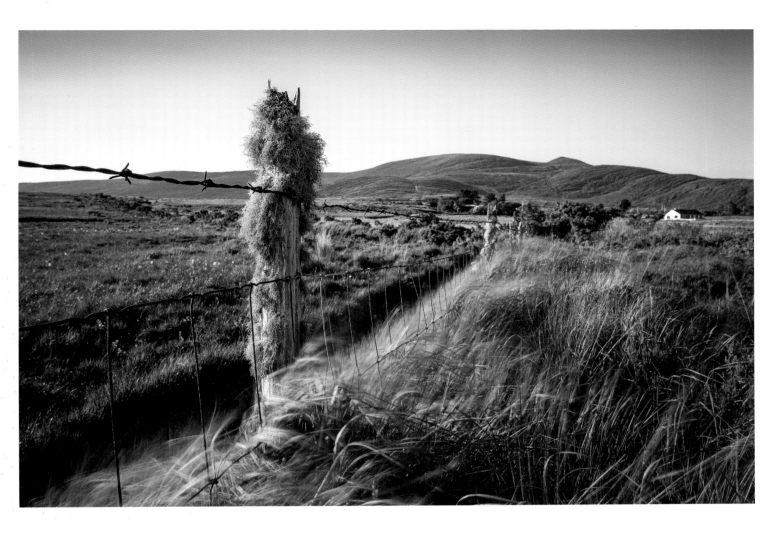

Opposite: This standing stone near the Inny Tavern, Killeenleagh, is identified on maps as an Ogham Stone, i.e. pre-Christian, and yet it features a Christian cross. An example of Christianity embracing an earlier set of beliefs and culture?
Above: Fence-post lichen.

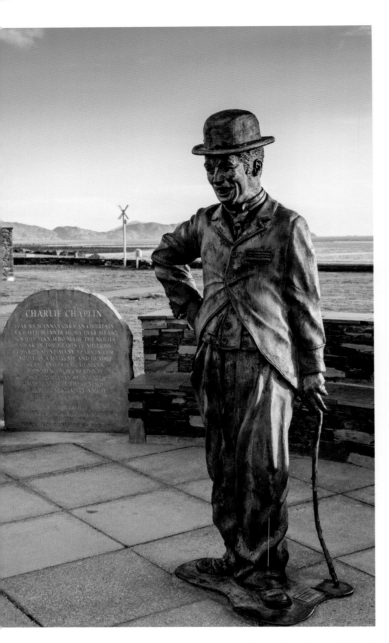 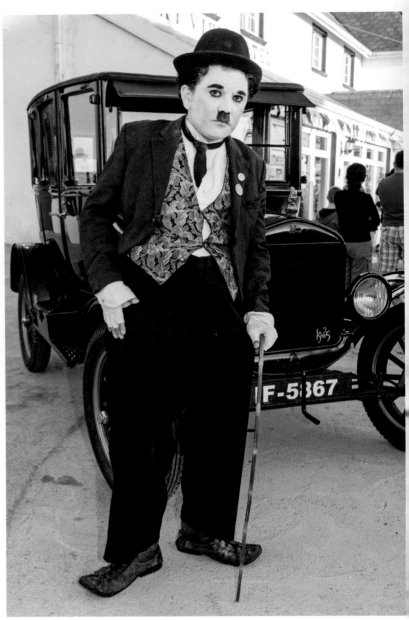

Above left: Charlie Chaplin and his family were regular visitors to Waterville. Chaplin visited the town in 1959 to try out the fly-fishing – on the recommendation of his friend Walt Disney, it is said. He returned throughout the 1960s. The bronze sculpture is by Valentia sculptor and artist Alan Hall. Keep your eyes open as there are many more of his sculptures throughout the county.

Above right: Street artist, Diego Spanó. There is a Charlie Chaplin film festival in Waterville each August, when new comedy films are showcased and all things 'Chaplin' are celebrated.

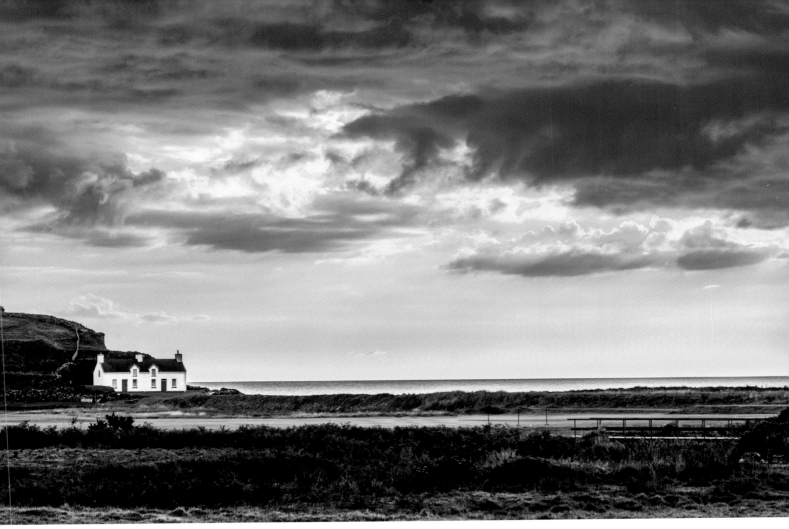

Above: Waterville sunset.

Right: John (the man) and Billy (the goat), complete with beards, can often be seen along the Ring between Waterville and Sneem.

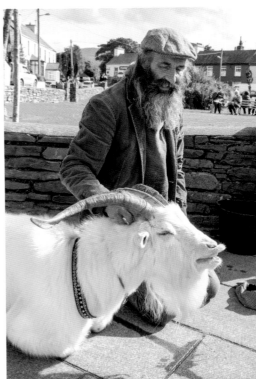

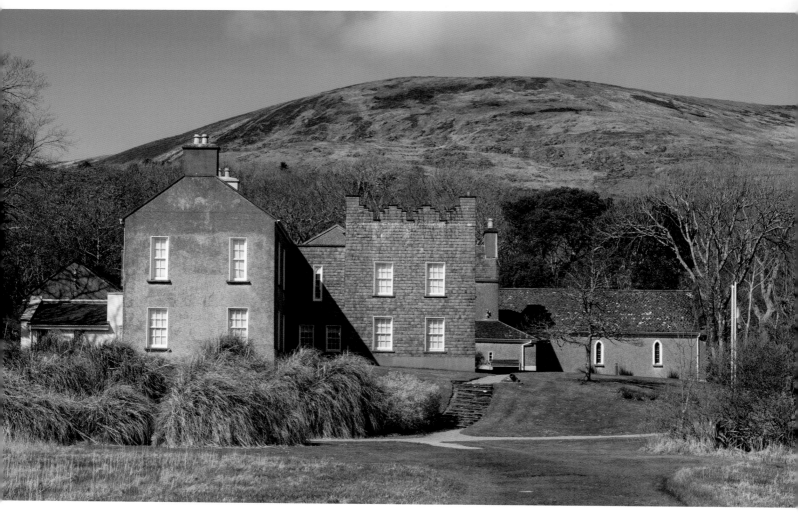

DERRYNANE

Above: Derrynane House, home of Daniel O'Connell, 'the Liberator'. A true Irish hero and a pacifist who fought hard to free Irish Catholics from Protestant oppression, O'Connell was born in nearby Cahersiveen in 1775. He studied law in France, where he witnessed at first hand the ugly violence of the French Revolution. Thus, if not already a pacifist, he certainly became one. O'Connell inspired Mahatma Gandhi's non-violent protest movement in his own struggles for Indian independence. Sadly, O'Connell did not manage to achieve his main goal: Home Rule and an independent Irish parliament.

Opposite top: Derrynane Abbey.

Opposite bottom left: Derrynane.

Opposite bottom right: Cows on the beach, Derrynane.

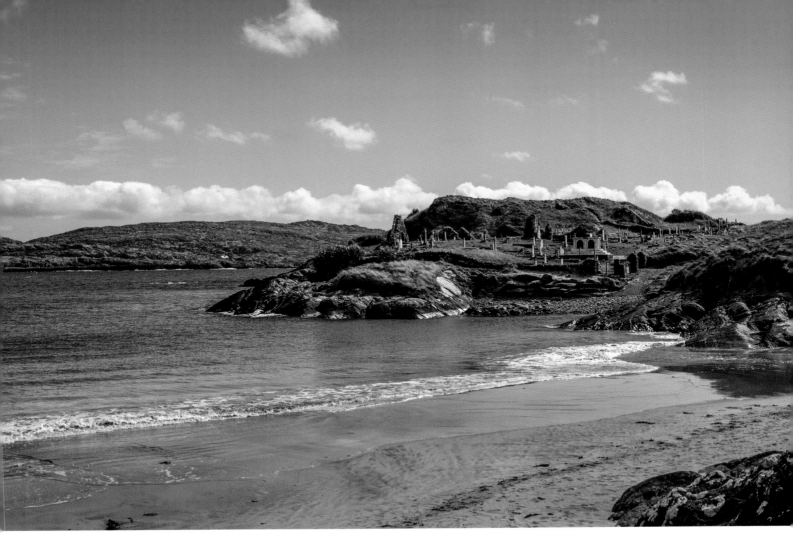

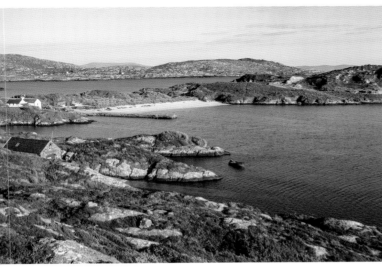

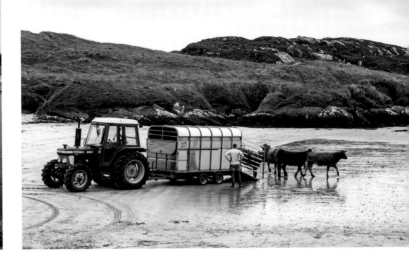

Below: During the time of the seventeenth-century Penal Laws, when attending church was forbidden, the 'Mass Path' brought locals from Scariff Island to the mass rock (a gathering place, with a large rock used as an altar) in Derrynane.

Opposite top left: Carroll's Cove, Ring of Kerry.

Opposite top right: Westcove House. This imposing Georgian manor house, overlooking Westcove Harbour and the Kenmare Estuary, is available as a holiday let.

Opposite bottom left: Staige Fort, one of the many Iron Age stone forts found in Kerry, and by far the largest. Built probably in the early centuries AD – it is a few miles west of Sneem.

Opposite bottom right: Honesty-box art.

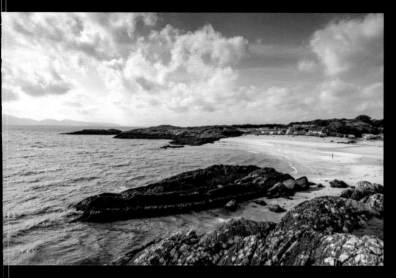
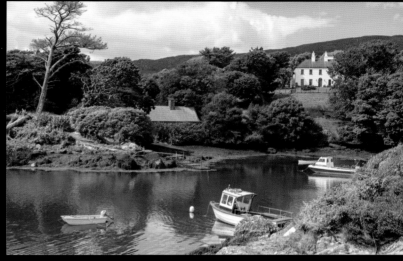
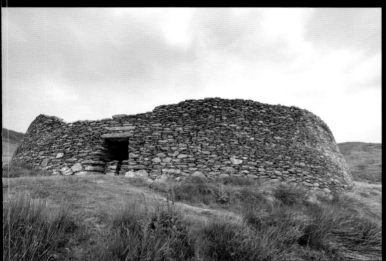

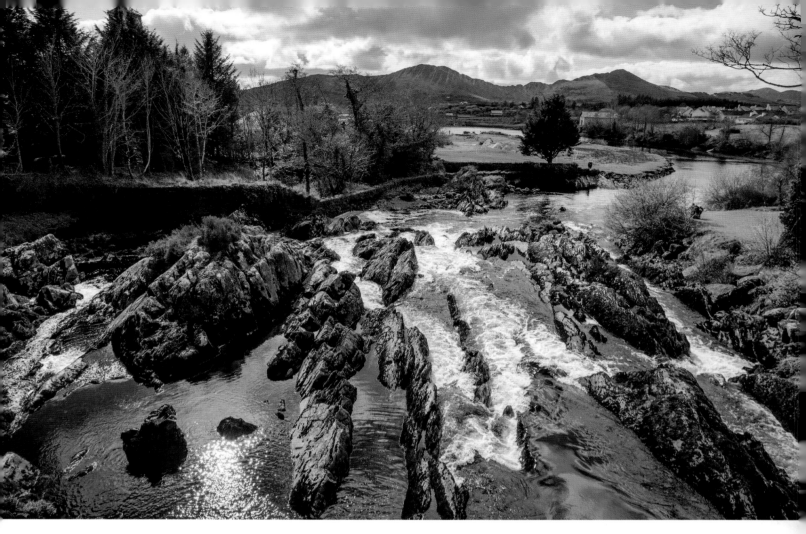

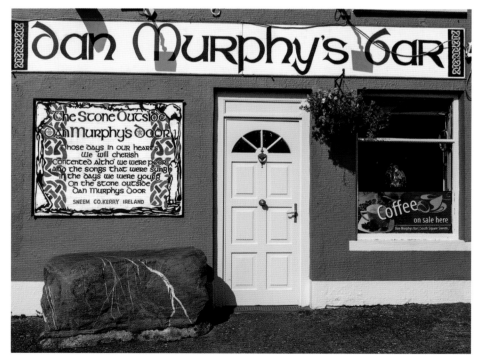

SNEEM

Above: Ever popular with tourists and returning visitors, the idyllic village of Sneem is neatly divided into two halves by a river of the same name. When crossing the footbridge, stand on the open steel grid and look down at the rushing water below – if you dare!

Left: Johnny Patterson (1840–90) wrote a song, 'The Stone Outside Dan Murphy's Door', a huge hit in its day, and stones appeared outside various Dan Murphy's bars around Ireland. The real one was in Ennis, Co. Clare.

Opposite: St Patrick's Day is celebrated nationally and internationally. The Sneem parade is one of the largest in Co. Kerry, always well attended and very colourful.

KENMARE

Below: A picturesque town, Kenmare provides a good base to explore the Ring of Kerry, as well as the Beara Peninsula beyond.

Opposite top left: Bar, Kenmare.

Opposite top right: Everything visitors might need is here and of high quality too. Restaraunts, pubs, craft shops, galleries, all within walking distance, located around the town's 'triangular' layout.

Opposite bottom: The Ring of Kerry near Kenmare.

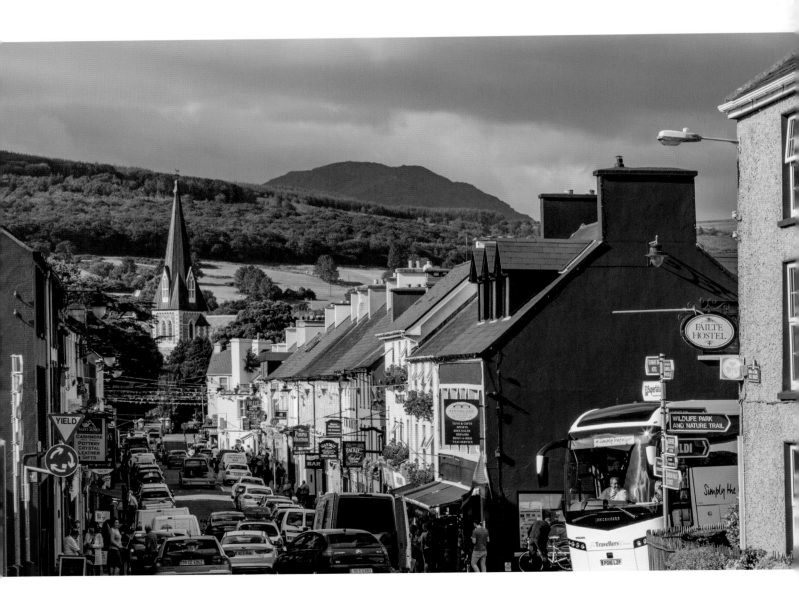

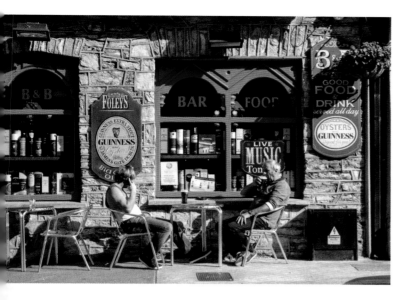

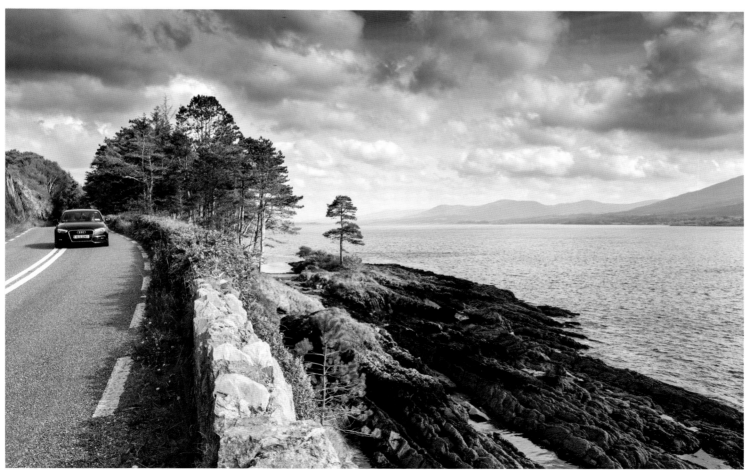

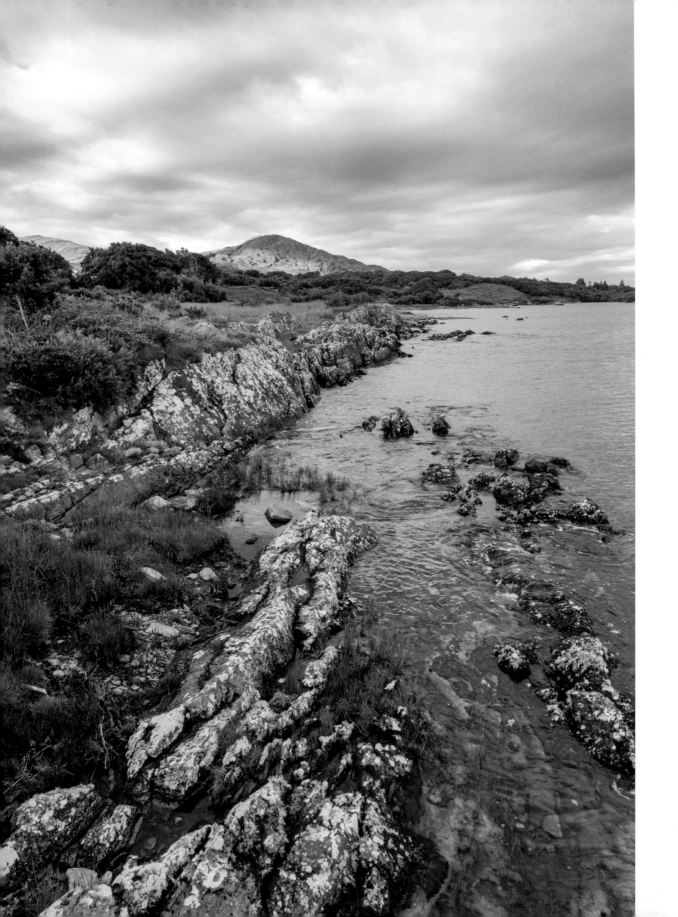

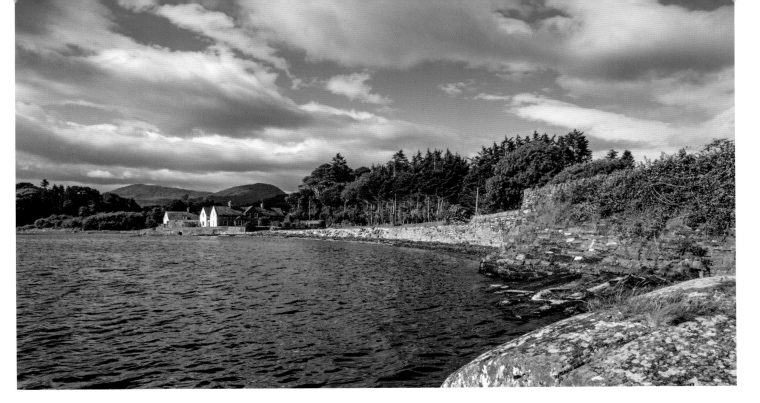

Opposite: Near Kenmare.
Above: Kenmare River.
Below: Kenmare Bridge.

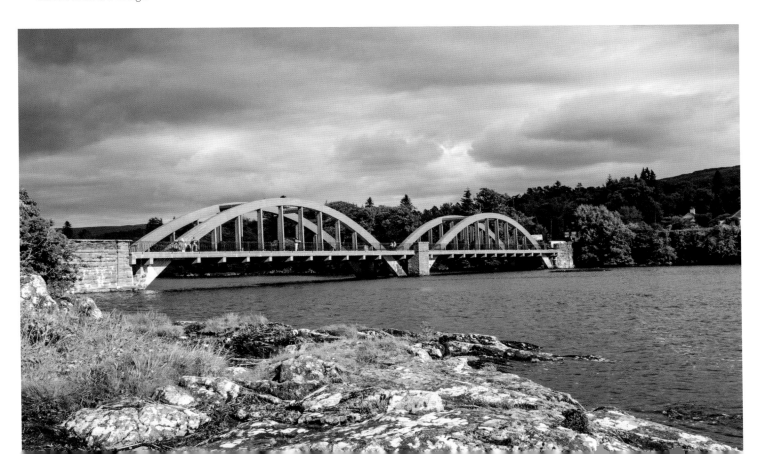

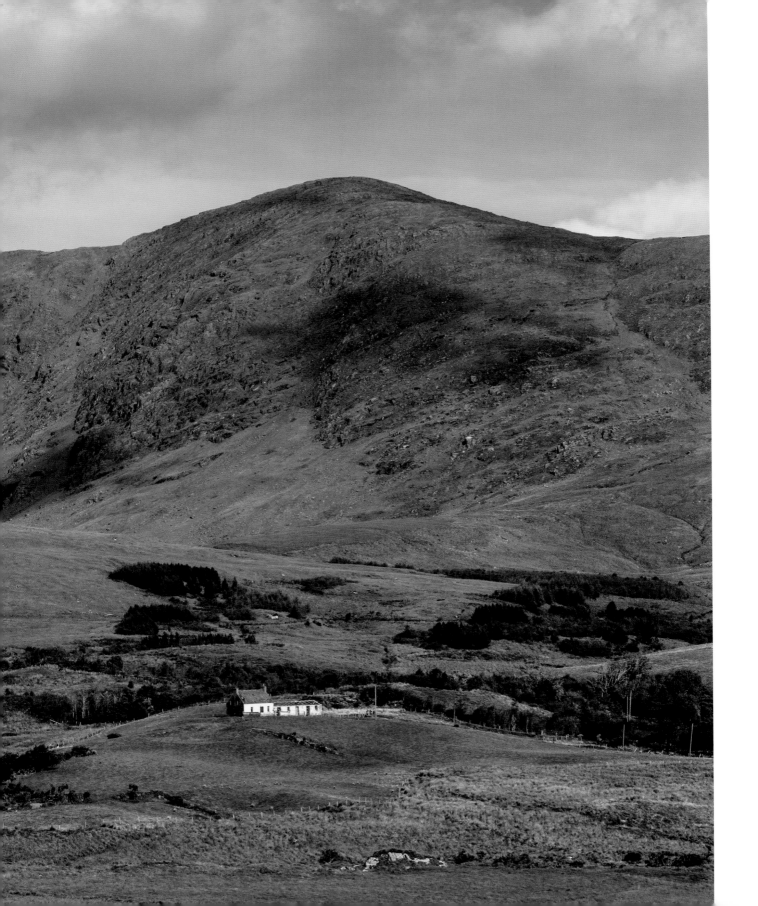

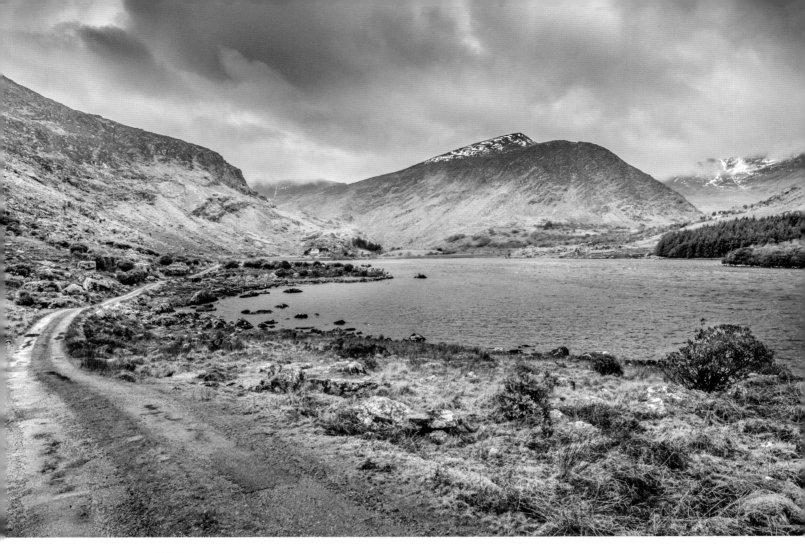

THE MOUNTAINS

Opposite: Kerry has several mountain ranges, and, though small by standards elsewhere, they are no less dramatic. Their close proximity to the sea means that most of the peaks can be observed and appreciated at their full height.

Above: Concealed in the Macgillycuddy's Reeks, the Black Valley is as inaccessible a place as it is possible to find in Kerry. Little has changed here since the end of the last Ice Age. Before you find it, miles of very narrow roads have to be navigated . . . and then they get narrower. If you are adventurous, enjoy being isolated from the world and are a lover of wild and relatively untouched natural majesty, you will certainly like it here.

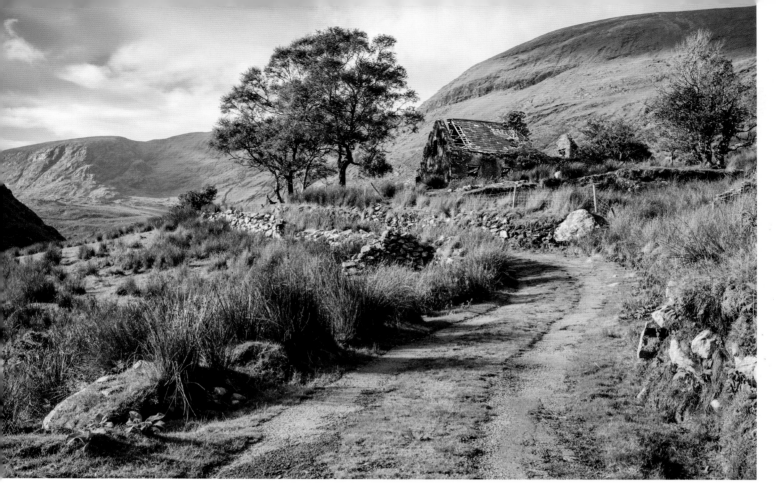

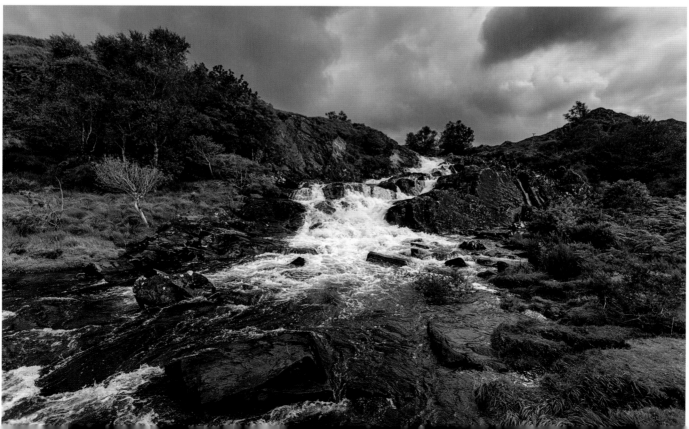

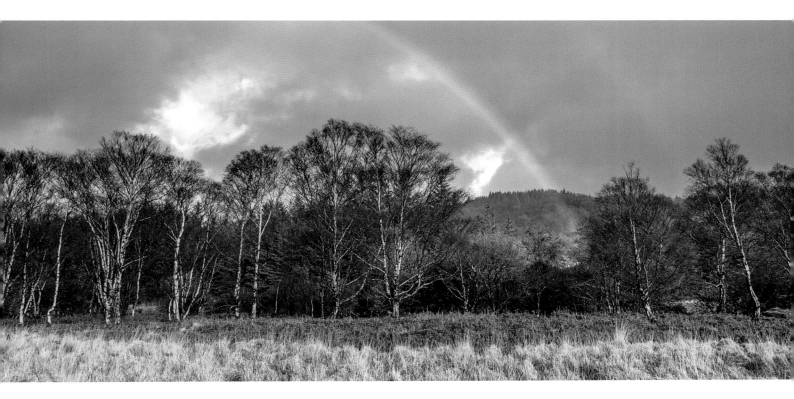

Opposite top: At the far west end of the Black Valley, this picturesque cottage ruin is in a truly beautiful location, with Carrauntoohil just a mile or two away. Walkers traversing the Kerry Way pass close by and will therefore be familiar with it. As the cottage is well off the beaten track, only the very adventurous motorists with little regard for their insurance excess will make it this far, and yet the journey is well worth it. If you are planning to visit, hurry, as the cottage is now in very poor condition and may not be standing for much longer.

Opposite bottom: Black Valley river.

Above: Black Valley rainbow.

Right: Black Valley ruin.

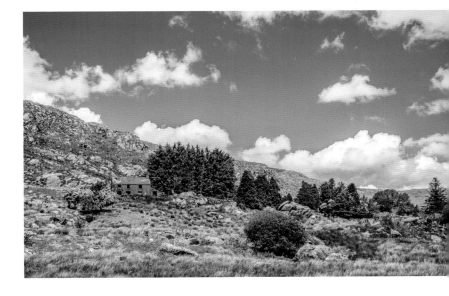

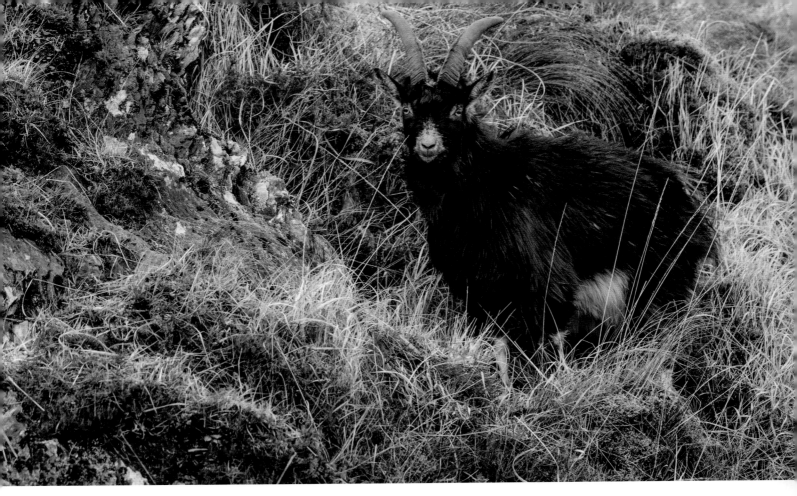

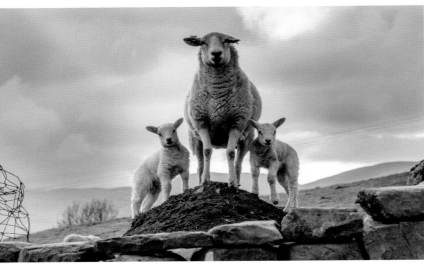

Above: Goats have been in Ireland for thousands of years, but the true wild 'old Irish' goat is very rare. Most are feral, having descended from runaway or deliberately released animals. This fine example was found grazing on a holly tree at the side of the road in the Ballaghbeama Gap. His curiosity lasted just long enough for me to take his picture.

Left: Mother and twins.

Below left: Under a tree under a mountain.

Below right: Turf stook. If you mention the smell of burning turf in a conversation, you will find it is a very sentimental subject to the rural Irish living abroad. A slight whiff as he drives along and the returning traveller knows he is home. Once familiar with it, you will never forget it.

Bottom: Lough Cummernamuck.

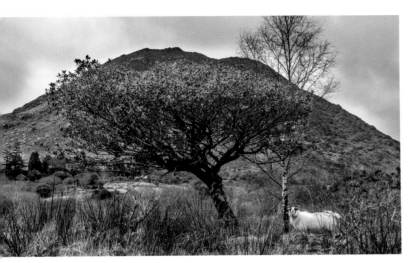

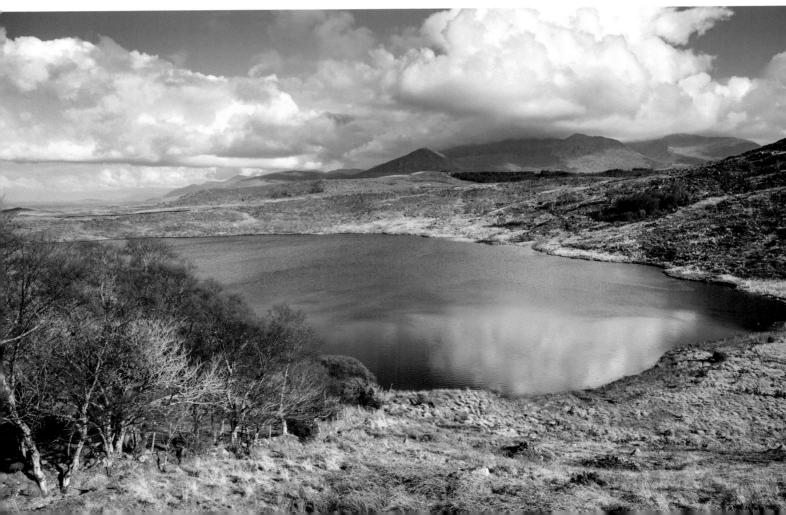

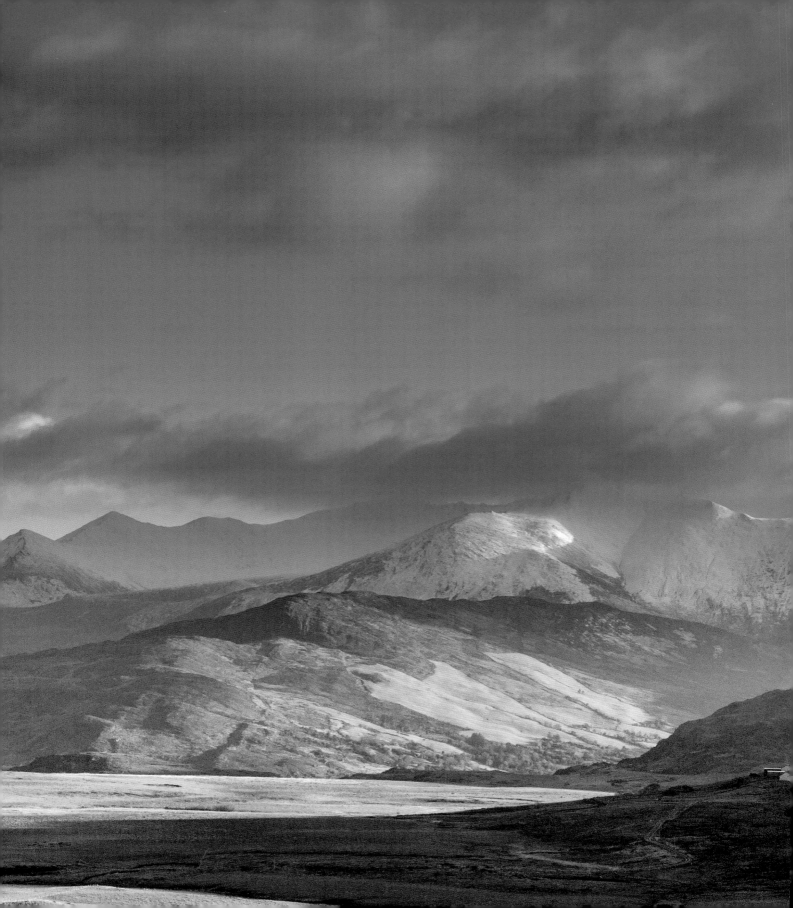

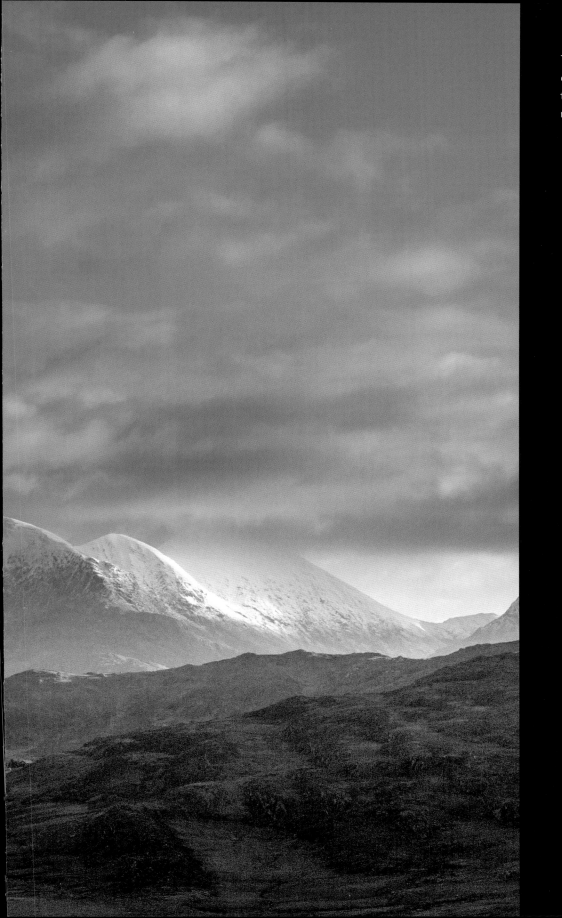

The Macgillycuddy's Reeks is the largest of Kerry's mountain ranges and home to Carrauntoohil, Ireland's highest mountain (1,038 metres).

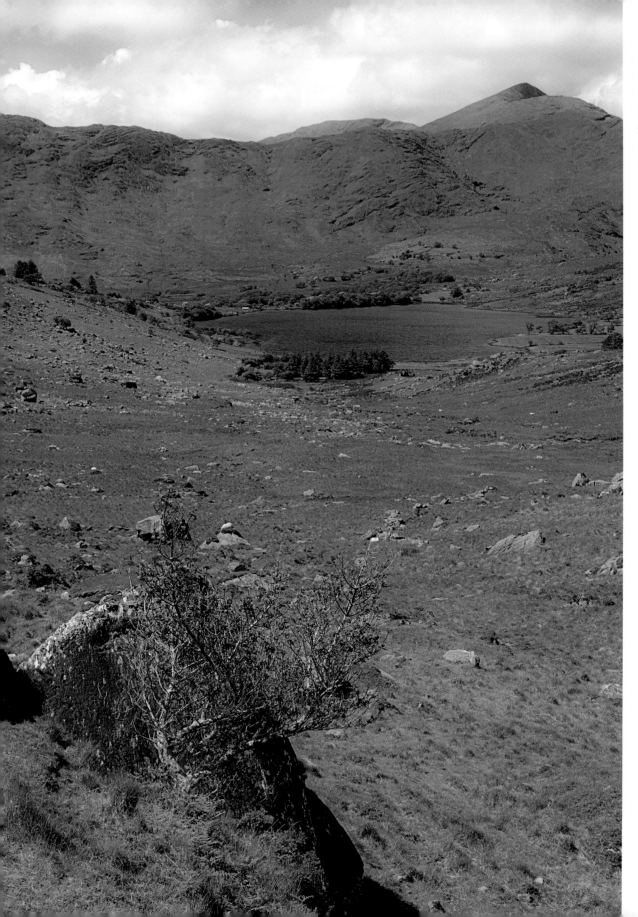

Left: Lough Bean.
Opposite: A small stream in the mountains and a long exposure contrasts the movement of the water with the still rock pool.

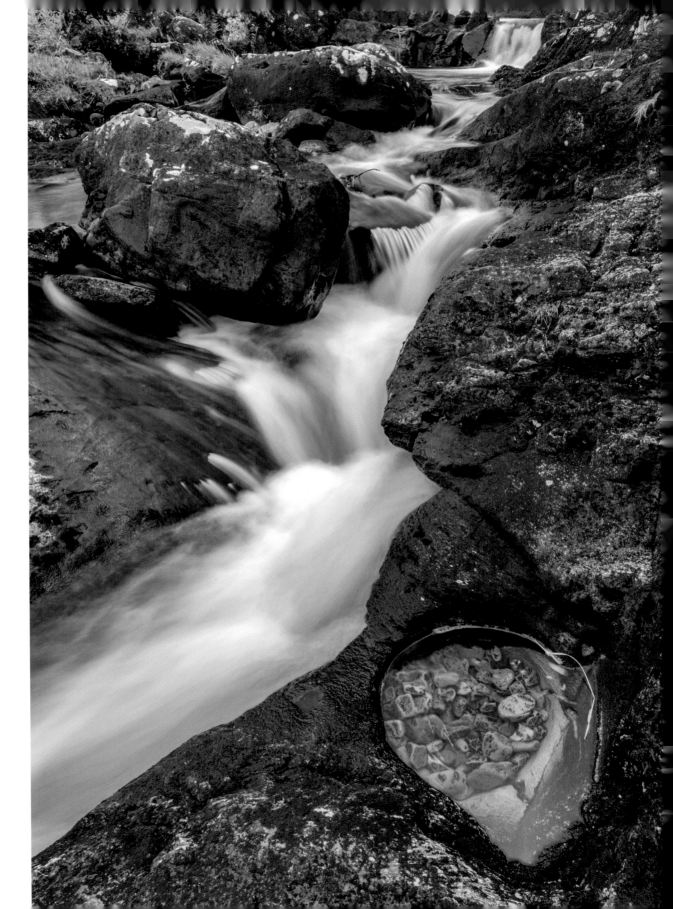

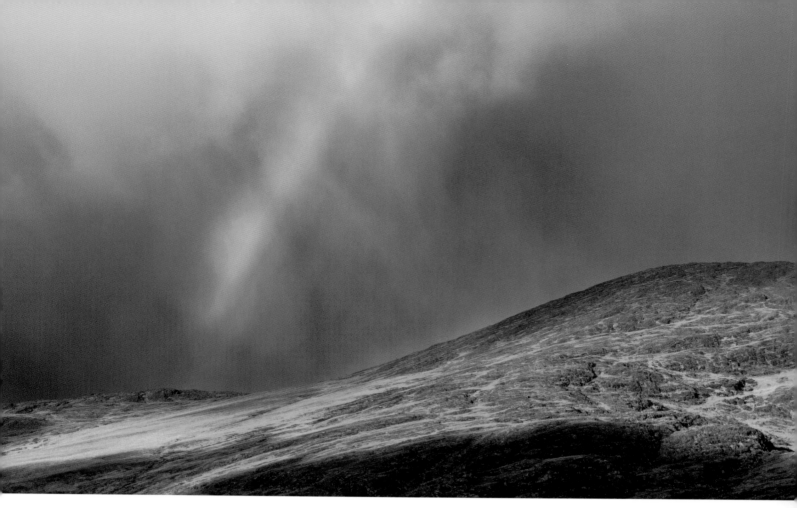

Above: Reeks rainbow.

Below: Kerry light.

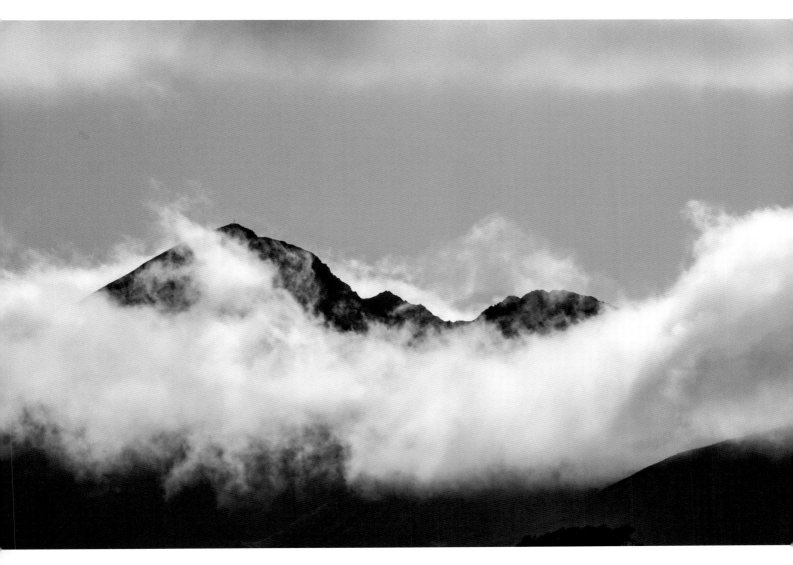

Above: Carrauntoohil.

THE GAP OF DUNLOE

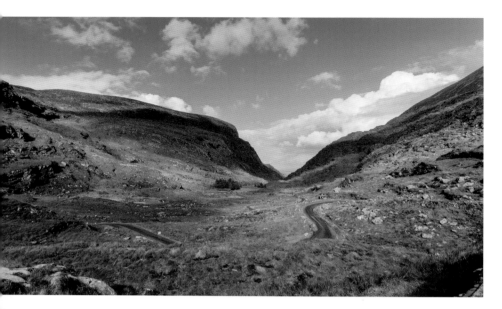

Left: Exploring the eleven kilometres from Kate Kearney's Cottage in the Gap of Dunloe to the summit (beyond which is the Black Valley) is probably best done on foot and can take more than two hours. The narrow road, with its many blind bends and humps, can be a real challenge in a car, especially in the summer when the 'jarveys' take to the road in their horse-drawn traps complete with tourists. If you do choose to drive, take care. However you choose to make the journey, you will not be disappointed, as the views and scenery here are outstanding. On this visit, in winter with snow on the Purple Mountain and the 'Wishing Bridge' over the river in full flow, I had the road to myself.
Bottom: The Gap of Dunloe.

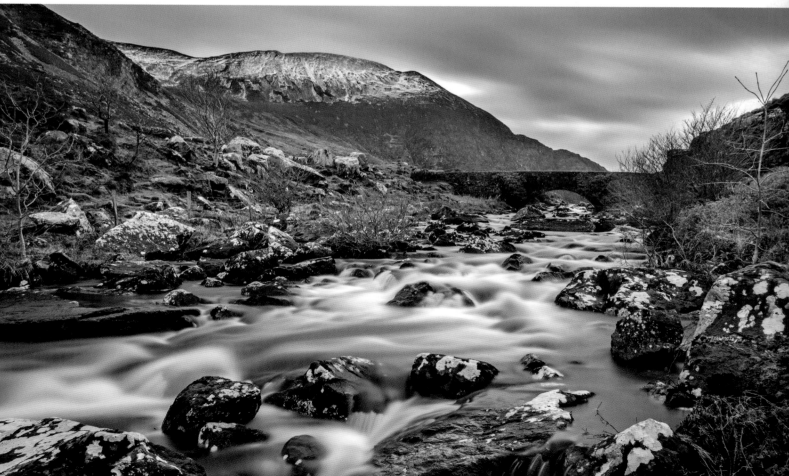

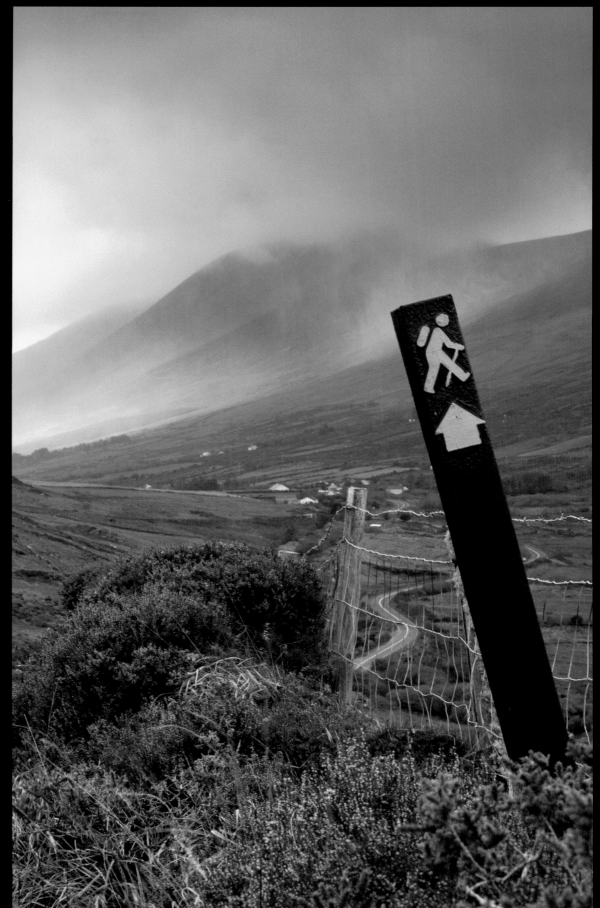

Right: Passing through the Black Valley is the Kerry Way. At over 200 kilometres, this is one of the longest signed trails in Ireland. Starting and finishing in Killarney, the Kerry Way passes through the lower reaches of the mountain ranges, avoiding the higher ground. Look out for the black posts featuring a yellow hiking figure, stick in hand. Also note the many black ladder stiles along the way which, like the signposts, are made from recycled plastic. For active regular walkers the trail can take nine days to complete, while others like to give themselves a little more time to enjoy a more leisurely stroll.

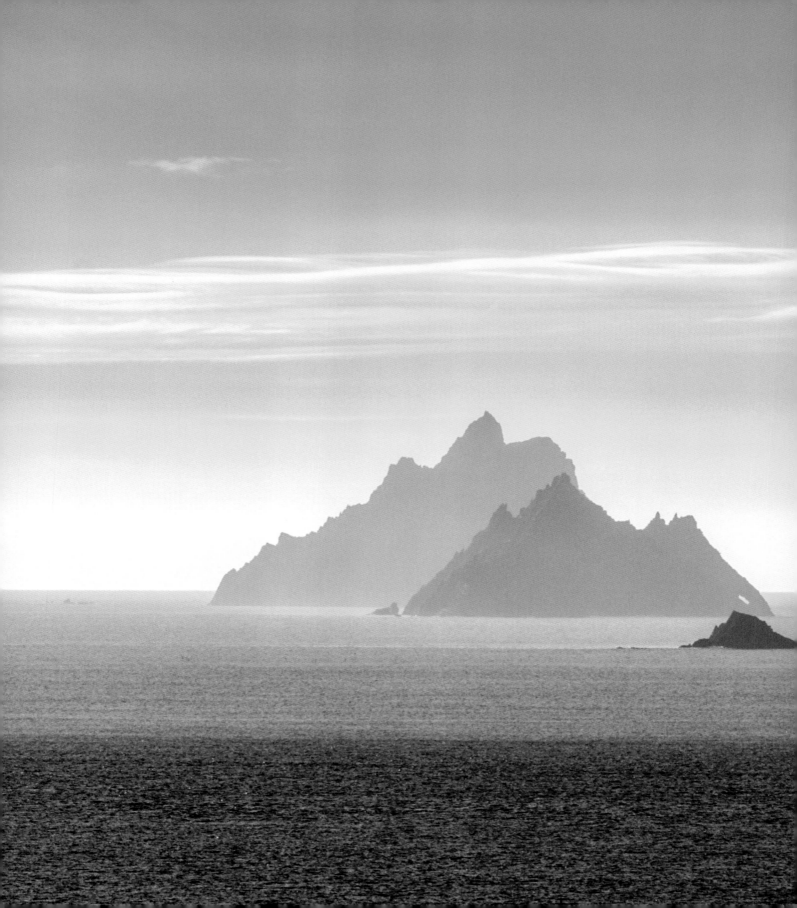

THE SKELLIGS

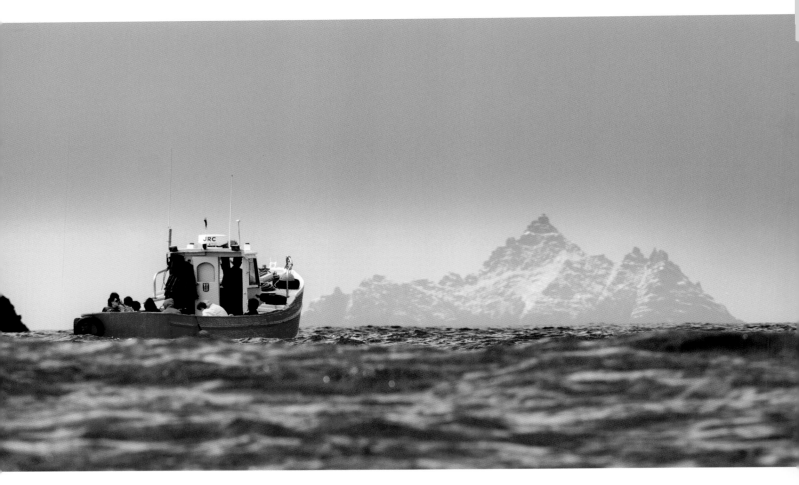

THE SKELLIGS

Above: Boatman Eoin Walsh on board the *Agnes Olibhear* heads out of the Portmagee channel with another group of lucky passengers. I first travelled out to the Skelligs nearly thirty years ago with local boatman, Dan McCrohan, on board his famous wooden boat, *Christmas Eve*. I have returned many times since, but that first trip, on a beautiful blue day in June, left an impression on me never to be forgotten.

Right: On the way out, some of the Skellig boats circle Little Skellig, giving an opportunity to see the seabirds and seals up close.

Previous page: The Skelligs seen from near St Finian's. The rock in the foreground is known as the 'Lemon Rock' and is actually just under 5 kilometres from the Skelligs. Projecting high into the sky, about 11 kilometres west of Bolus Head on the Iveragh Peninsula, the jagged, teeth-like Skellig Islands are truly an impressive sight. An excursion to this UNESCO World Heritage Site should be on every visitor's to-do list (weather permitting), although the trip is neither for the faint-hearted nor for those who suffer from vertigo.

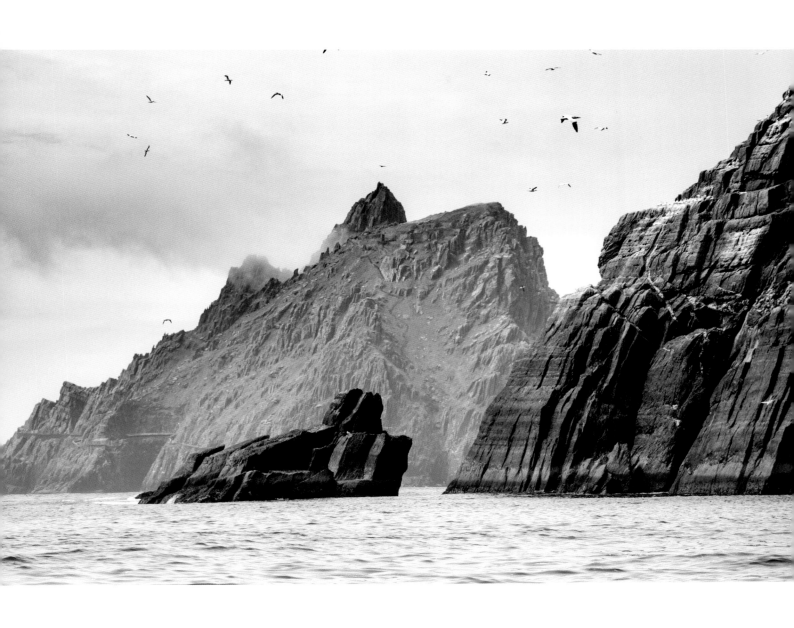

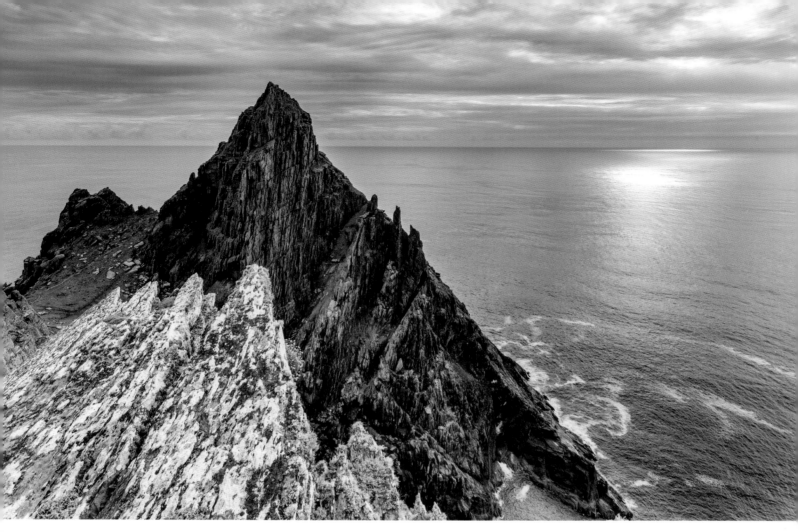

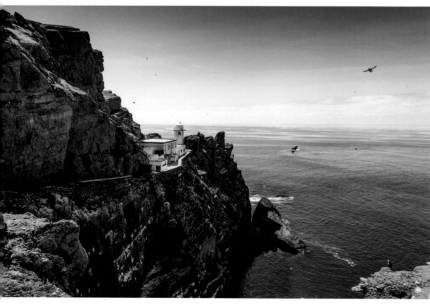

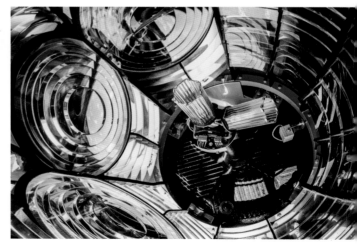

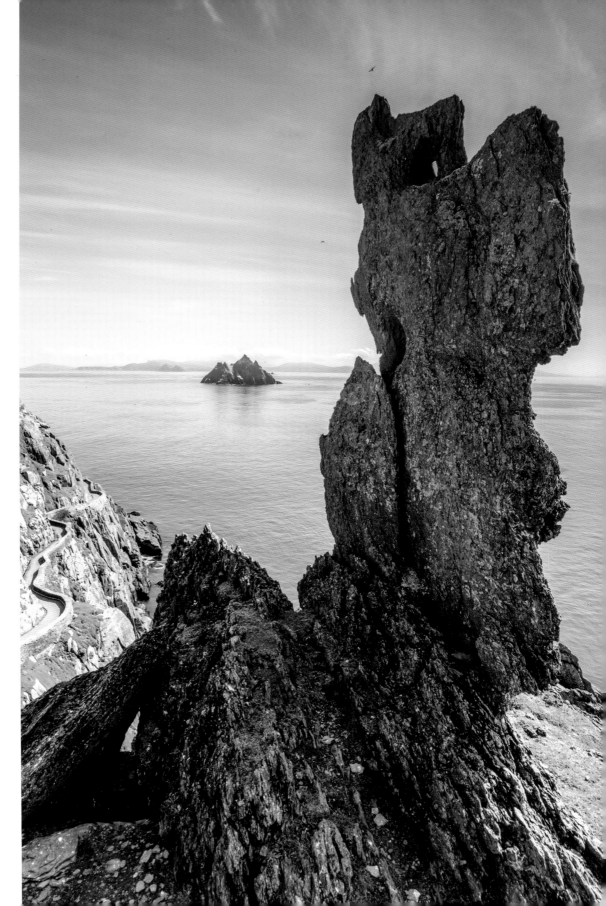

Opposite top: South peak, Skellig Michael.

Opposite bottom: Skellig Michael lighthouse is one of the main lights off the south-west coast of Ireland. It was built to replace the original lighthouse higher up on the rock, as this was often obliterated by low cloud. The light was converted to fully automated operation in 1987, meaning it no longer needed to be manned by a lighthouse-keeper. This had previously been a job for tough individuals who preferred a quiet, solitary life. In 2012, a new LED light was installed.

Right: The Wailing Woman, Skellig Michael. It cannot be a coincidence that the stairway leading up to the monastery passes so close to this huge monolith. Visible from the mainland, the Wailing Woman was named by the early lighthouse-keepers, who thought it resembled a sad and lonely figure silhouetted against the skyline.

Right: The stone stairway to the monastery at the top of the island, while breathtaking for many reasons, is heavy going and extremely steep. You do need to be fit and able to trek to the summit of Skellig Michael, but the rewards are worth it.

Below: After climbing the 600+ steps almost to the peak, there on a small terraced plateau you will find the monastic settlement: a collection of six *cloghàns* (beehive huts) and two oratories. Built possibly as early as the sixth century and probably founded by St Finian, at 700 feet above sea level, a more remote place of splendid isolation is hard to imagine. For 600 years monks lived, worked and prayed here. During this time, the monastery survived a number of Viking raids before being abandoned some time in the twelfth century, when the monks relocated to Ballinskelligs on the mainland.

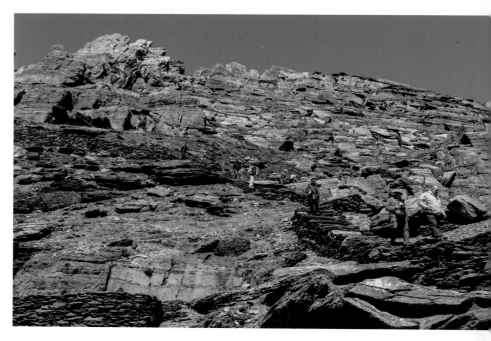

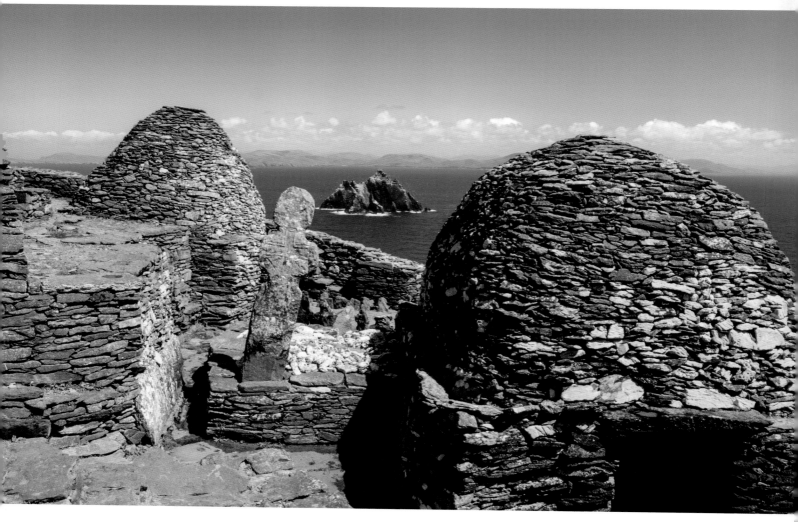

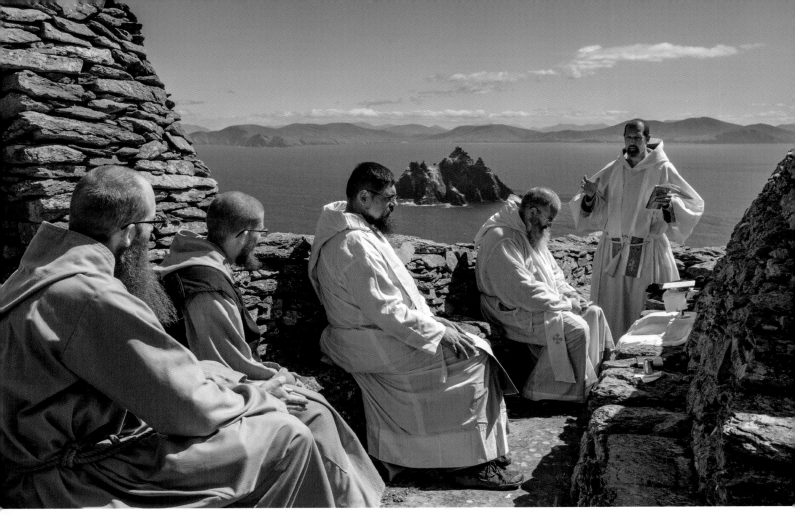

Above: In the spring of 2015, I had the good fortune to attend and photograph a mass held on Skellig Michael within the remains of the monastery there. The mass was conducted by six Franciscan friars hailing from America and France, who live in, work with and support the community of Moyross, Co. Limerick. They had travelled to the Skelligs on a mission to go back to the roots of their faith, to explore its history and to anchor themselves in this historical landscape. The whole experience was humbling and quite emotional. I hope that I have captured some of the spirit and solemnity of the service in this photograph. The friars were great company, interesting, humorous and very entertaining. I felt extremely honoured to have been invited into their assembly and to be able to observe their worship.

Right: Skellig window.

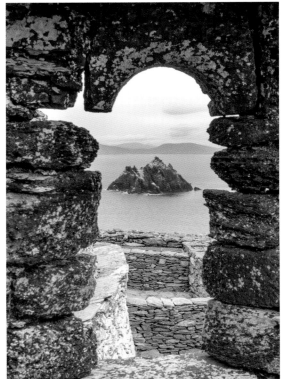

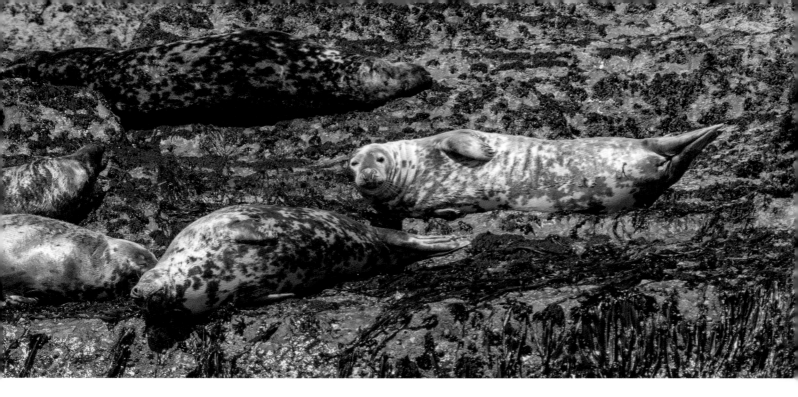

Above: Grey seals in repose on Little Skellig.

Below: Little Skellig is home to nearly 30,000 pairs of nesting gannets, one of the largest colonies in Europe. From a distance, it looks like a snow-covered peak under a cloud of flying snowflakes. Up close it is a chaotic mass of birds on the wing or clinging to their guano-limewashed summer home. If you are lucky enough to have fine weather and a sea calm enough to take a boat ride out, look out also for some of the other residents, including razorbills, kittiwakes and guillemots . . . and brace yourself for the smell of all of that guano!

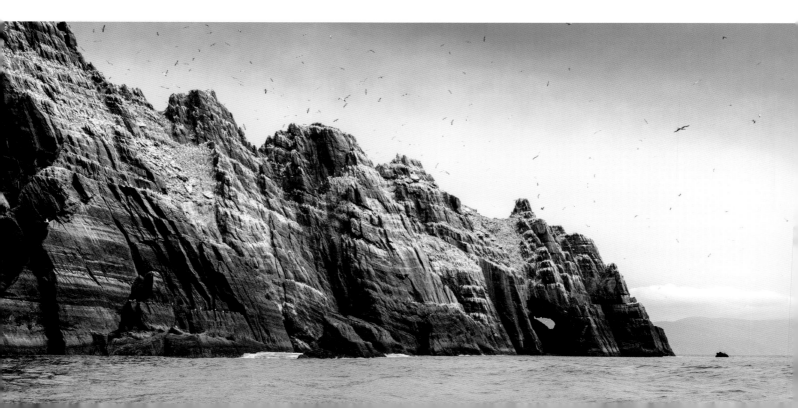

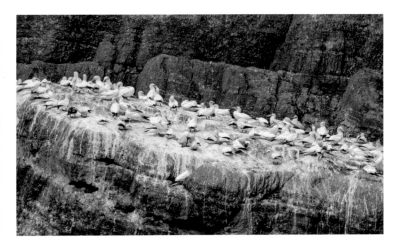

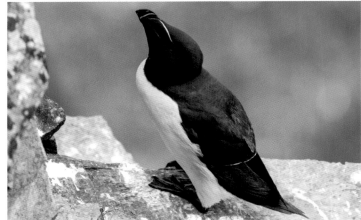

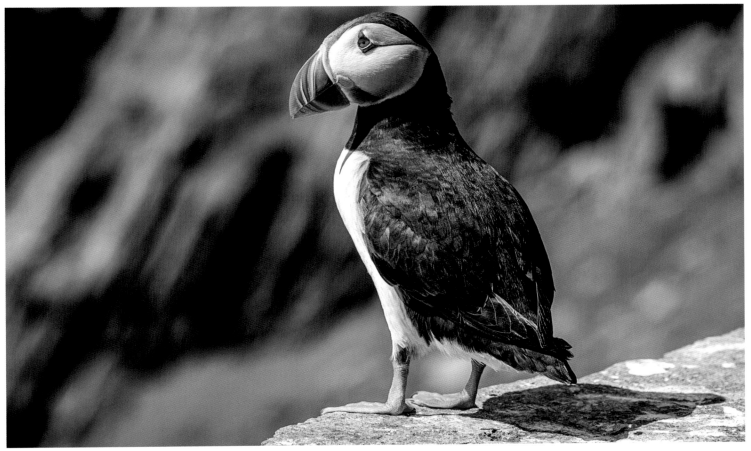

Top left: Little Skellig gannets.

Top right: As well as the many puffins, the larger razorbill can also be found on the Skelligs.

Above: Puffins are comical little characters, with their black and white suits and big, colourful beaks. They have unique appeal and are the stars of the Skelligs. Many people go just to see them, the Skelligs being an added bonus. Often referred to as the 'clown of the seas' or the 'sea parrot', the comedic quality of the puffin's appearance belies its ability to survive and thrive in often harsh Atlantic conditions.

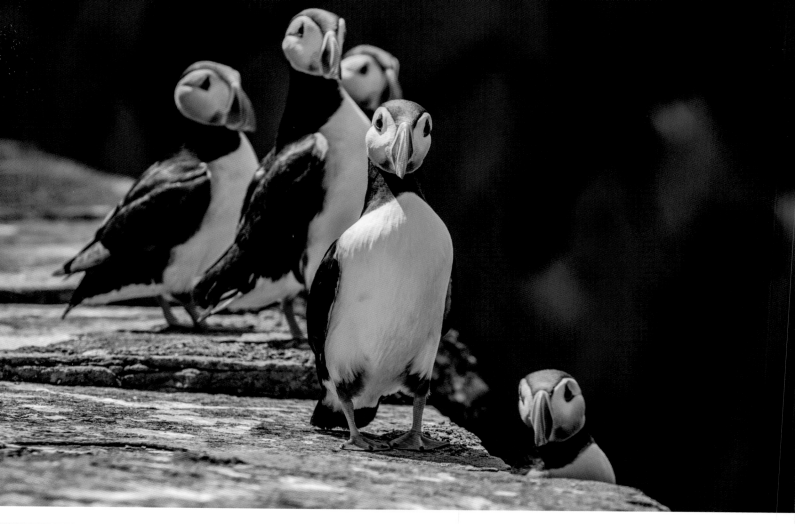

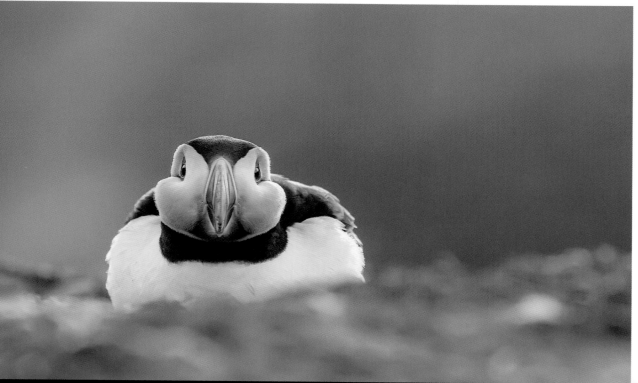

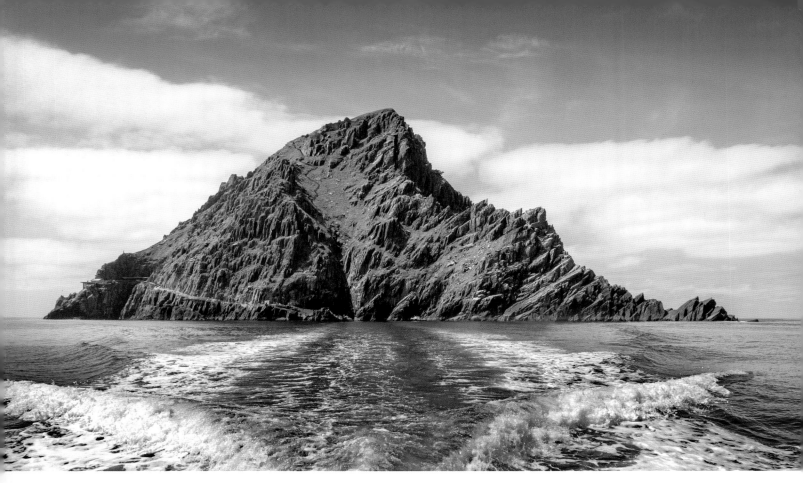

Above: It does indeed take time to feel 'real again' after the sensory overload that accompanies a trip to the Skelligs. Some trippers retire to the nearest pub immediately on disembarking, to try to recount and make sense of what they have just experienced, to take it all in. Others unlucky enough to have chosen a bad weather day may wish they had not opted to go out – the wet, rough misery of it all. Do choose a nice day if you can.

Right: Unsurprisingly this 'incredible, impossible, mad place' was chosen by Hollywood as a location for filming *Star Wars: The Force Awakens*. This caused a great deal of controversy and consternation from environmentalists, as shooting Part I of the new trilogy took place in July, while the puffins were still nesting. The hullabaloo led to the Irish government sending a navy vessel to safeguard the area; quite how the crew and their firepower on board *LE Samuel Beckett* were to help the puffins and shearwaters in their burrows was never explained. Thankfully, filming Part II of the trilogy was left until September when the birds had already left the islands, and Part III took place at a separate location on the Dingle Peninsula at Ballyferriter, much to the relief of ornithologists and our feathered friends alike. *Star Wars* fans are now among the many looking for a boat ride to this ancient place, so don't be surprised if you find yourself sitting next to a Yoda or a Rey.

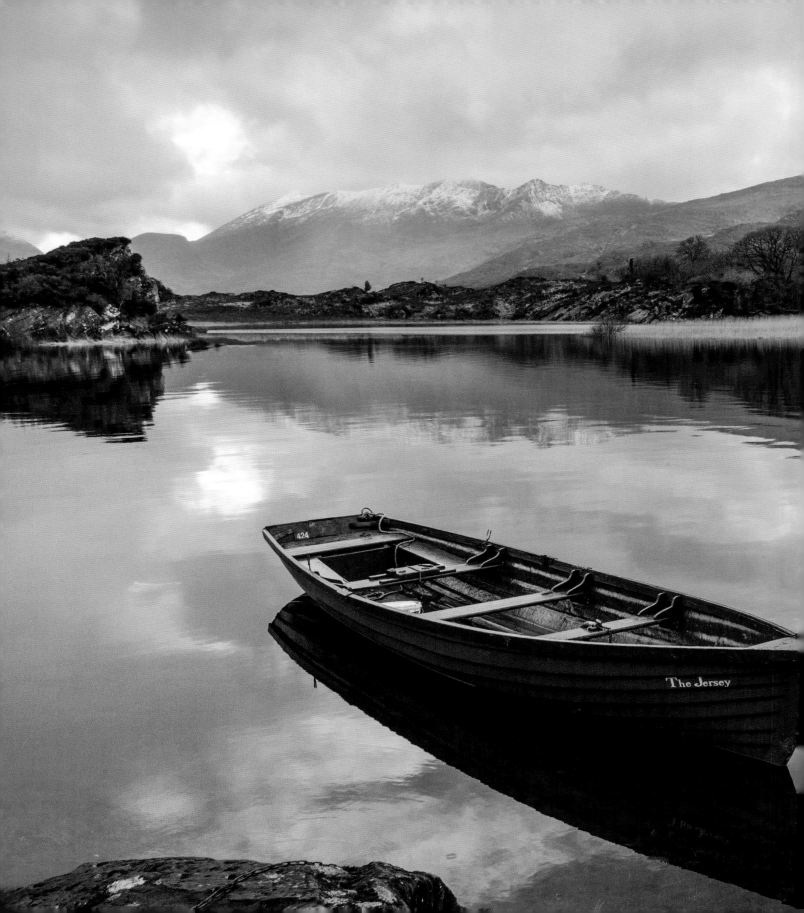

KILLARNEY

KILLARNEY

SITUATED ON THE SHORES OF LOUGH LEANE, Killarney is the tourist capital of Ireland and centrally placed within the county. The breathtaking Macgillycuddy's Reeks, the Gap of Dunloe and the Black Valley are all nearby, and there is hiking, angling, golf, cycling, pony-trekking, wildlife (and photography!) all on the doorstep.

Above: Killarney is busy with visitors all year round and is a popular base from which to explore the region. The town is also the setting-off and end point for tour buses navigating the Ring of Kerry.

Opposite top and bottom: Killarney town.

Previous page: The Upper Lake, Killarney.

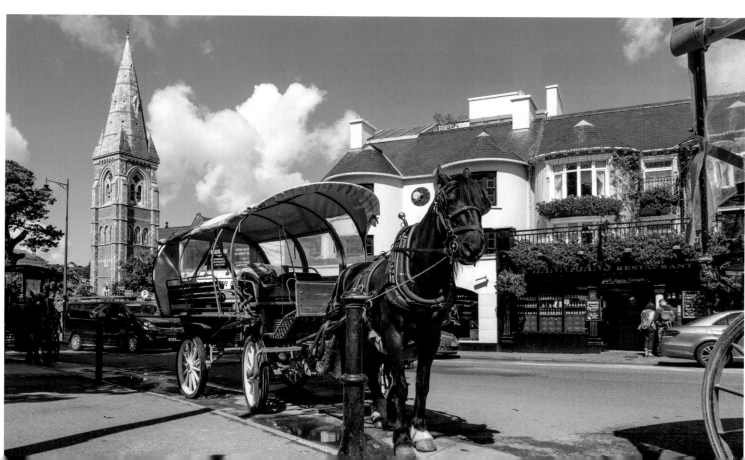

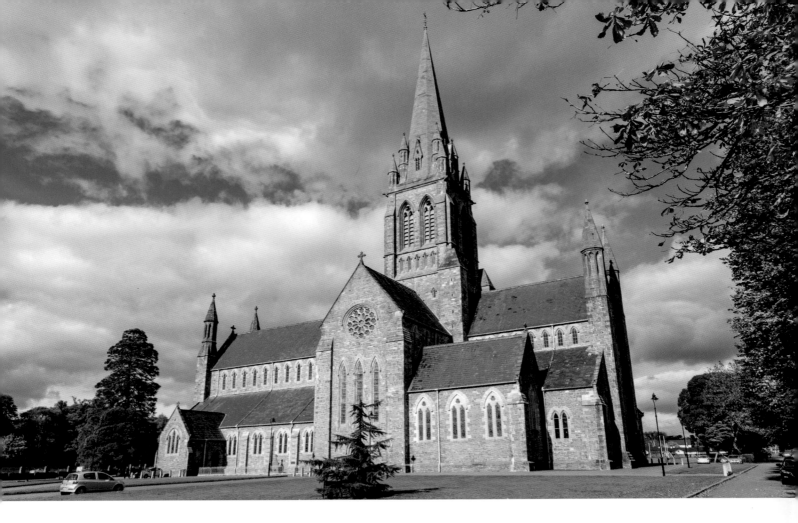

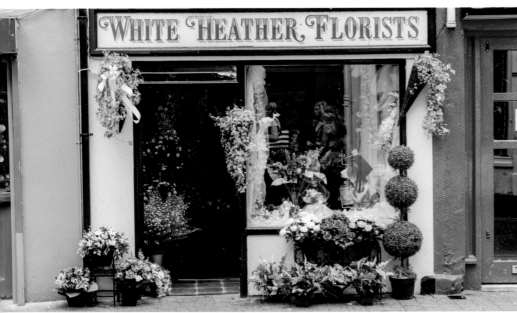

Above: St Mary's Cathedral.

Left: White Heather Florists. I once heard it said that the Irish choose their colours like emperors. No muted, dowdy or pastel shades in Killarney.

Below: In contrast to much of the rest of the county, things are somewhat more commercial in Killarney – but no less interesting. When recording your holiday, try getting in close … and then a little closer.

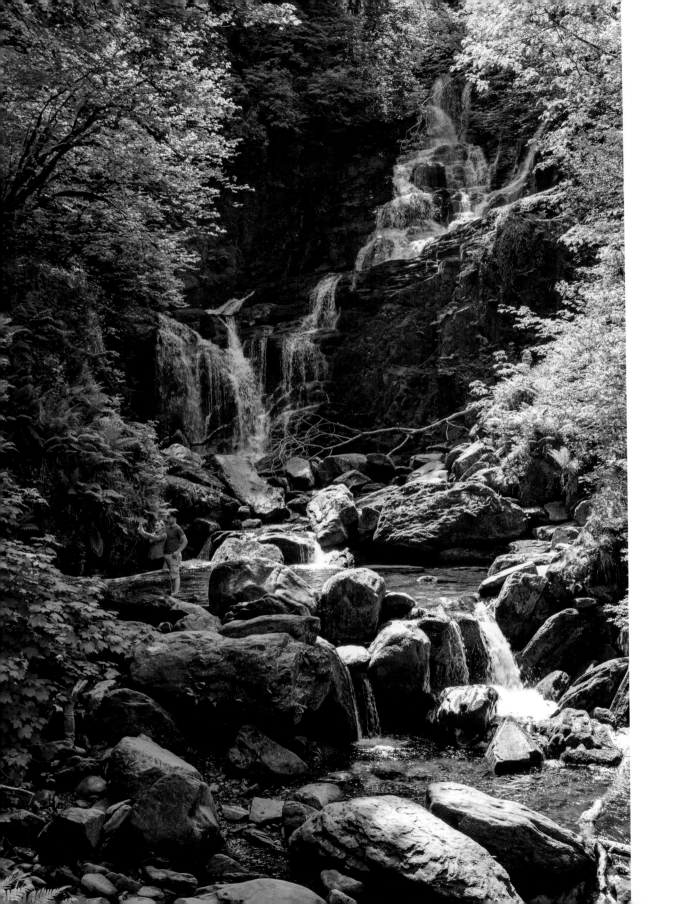

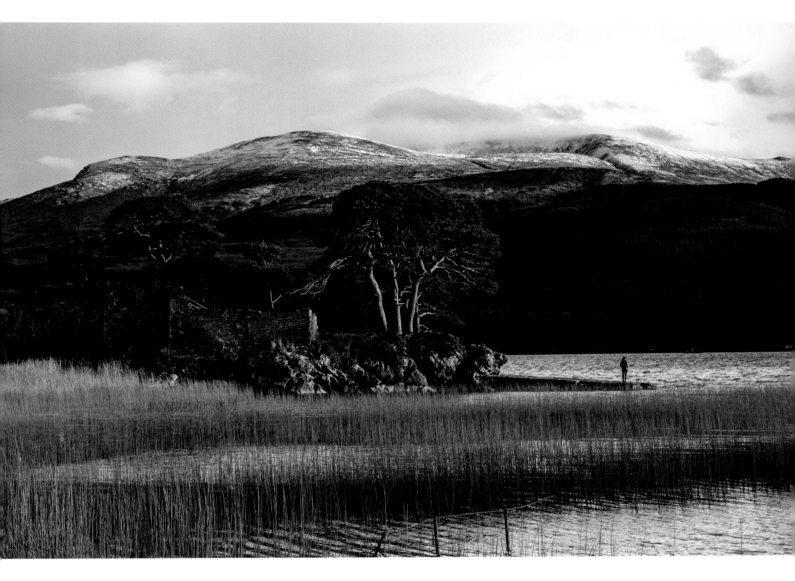

Opposite: Torc Waterfall.

Above: McCarthy Mór Castle, Lough Leane.

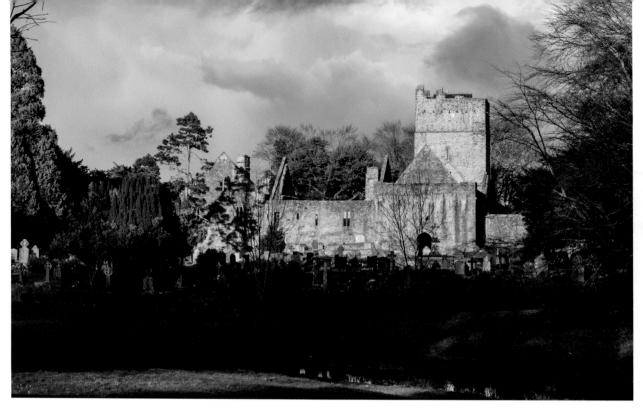

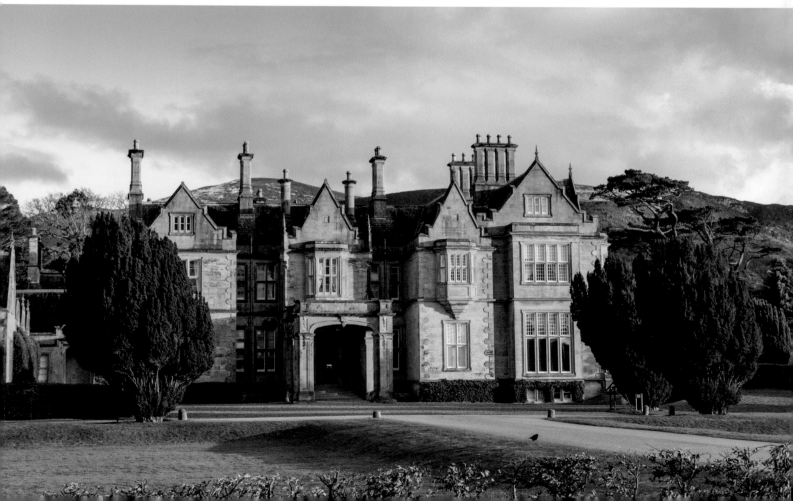

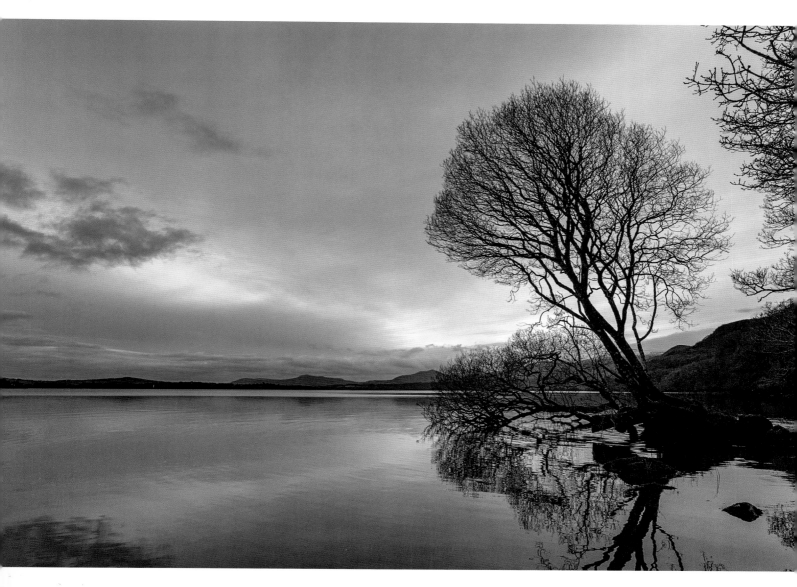

Opposite top: Muckross Abbey. The Killarney National Park sits on the very edge of the town, along with Muckross House, Muckross Abbey and Ross Castle, situated in ancient woodlands.

Opposite bottom: Muckross House.

Above: Evening, Lough Leane.

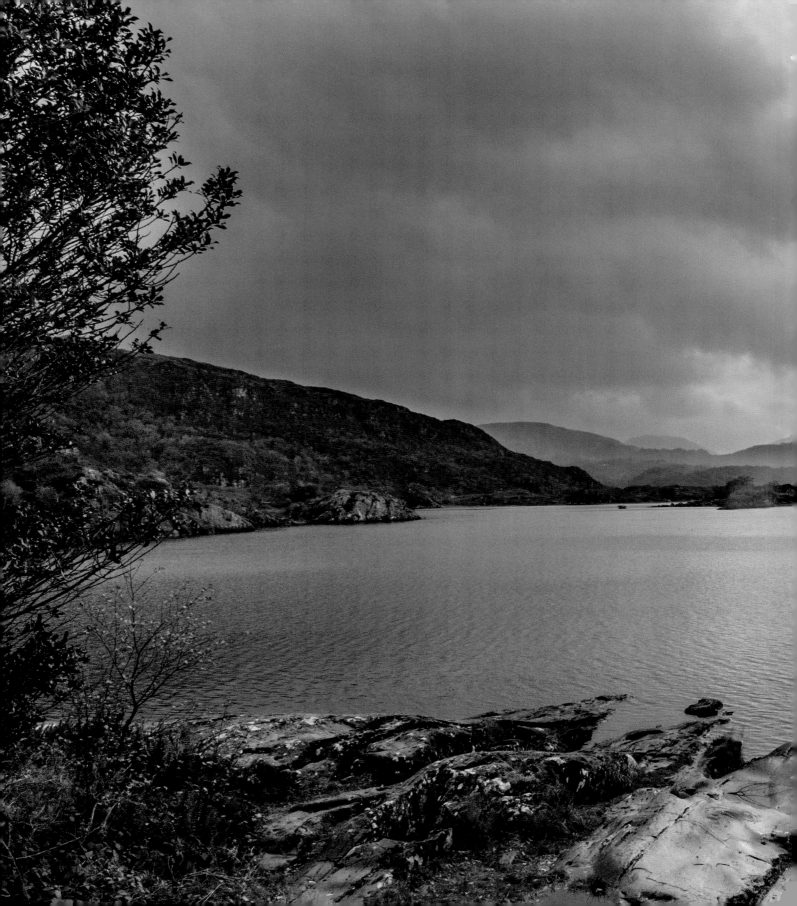

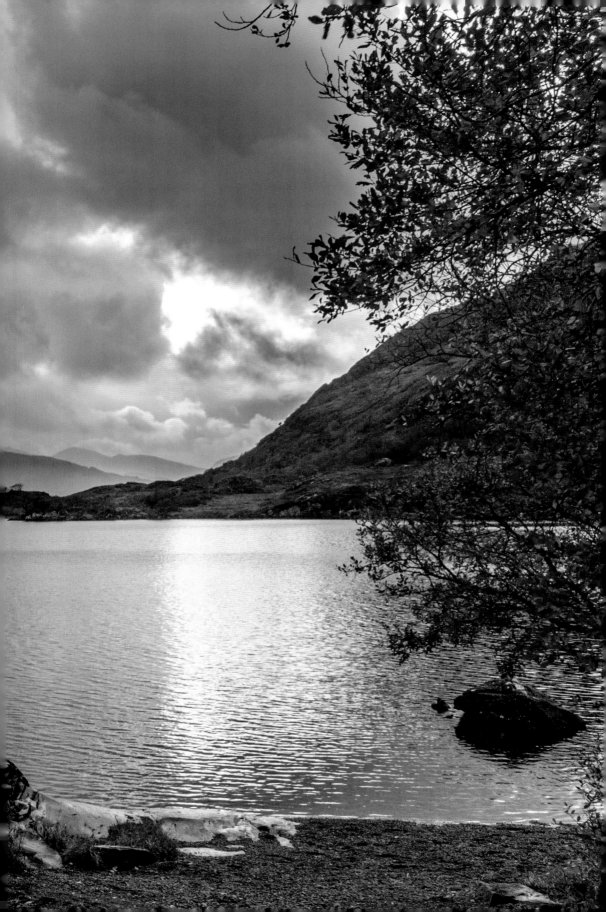

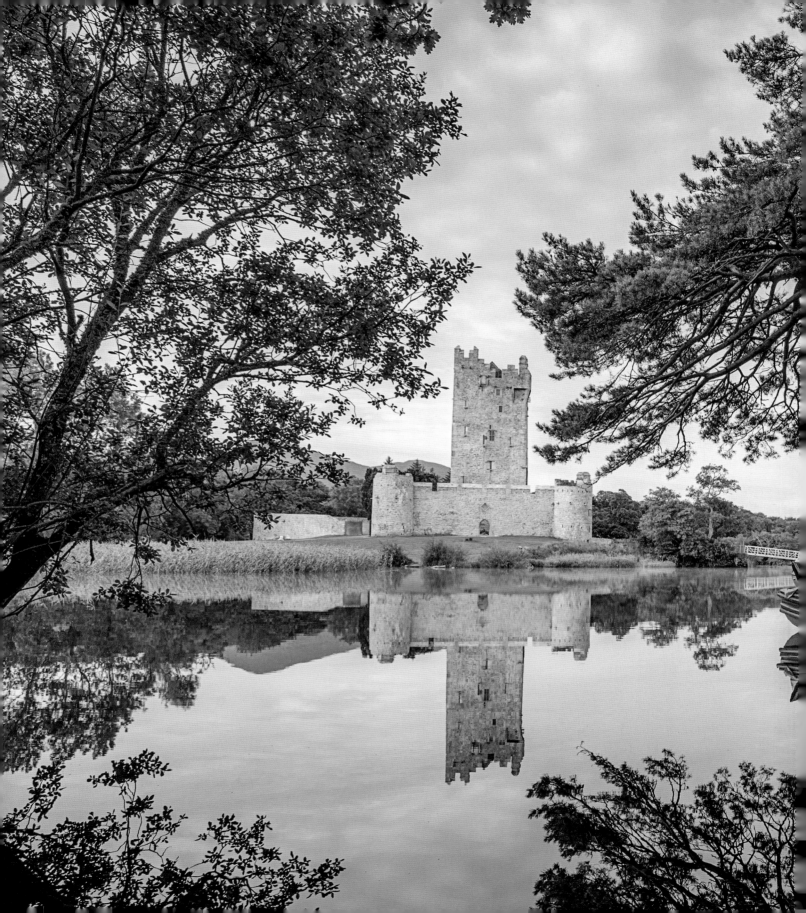

Above: Lord Brandon (1771–1832), a local gent, built a hunting lodge in a splendid location by the Upper Lake. Now a café, it is possible to take a boat ride there from Ross Castle or Muckross House. This is an enjoyable excursion into the heart of the Kerry wilderness, and the return can be by jaunting car or vintage bus, taking in the Black Valley and the Gap of Dunloe.

Previous page: Ross Castle is believed to have been built in the fifteenth century by one of the O'Donoghue Ross chieftains. An imposing defensive stronghold, perfectly placed on the shores of Lough Leane.

Below: Often referred to as 'famine cottages', these tiny dwellings were abandoned in the mid-1800s when the potato crop failed and famine gripped rural Ireland. One million people died of starvation, and two million were forced to emigrate. Ireland's population numbers have never recovered to pre-Famine levels.

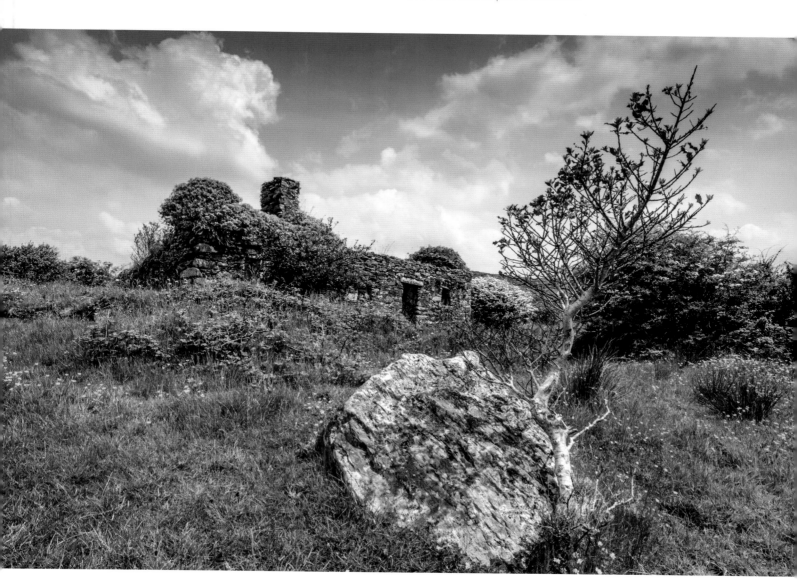

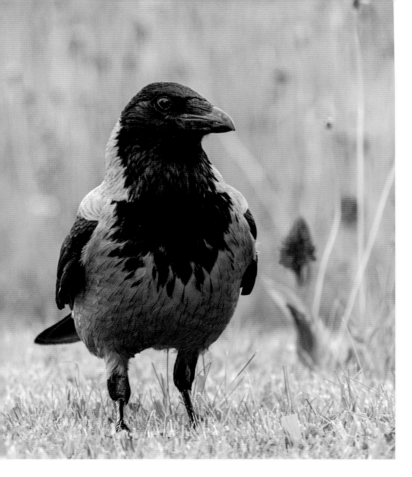

Left: The hooded crow, also known as the grey crow. This handsome yet sinister bird is an opportunist, and not averse to pecking the eyes from the dead or dying.

Below: It is hard to believe that fuchsia is not a native plant to Kerry. Having come from South America a little over a century ago, it now lines hundreds of miles of lanes, tracks and boreens. The temperate climate, and fuchsia's ability to spread from broken twigs and branches, have helped its bright colours dominate many of the Kerry hedgerows.